(Collins

WATERCOLOUR LANDSCAPES from Photographs

WATERCOLOUR LANDSCAPES from Photographs

CONTENTS

First published in hardback in 1998 by HarperCollins*Publishers* 77-85 Fulham Palace Road Hammersmith London W6 8JB

The HarperCollins website address is www.fireandwater.com

Collins is a registered trademark of HarperCollins*Publishers* Limited

This edition first published in paperback in 2001

© Ron Ranson, 1998

Ron Ranson asserts the moral right to be identified as the author of this work.

All rights reserved. No part of this publication may be reproduced, stored in a retrieval system, or transmitted, in any form or by any means, electronic, mechanical, photocopying, recording or otherwise, without the prior written permission of the publishers.

A catalogue record for this book is available from the British Library

Project editor: Caroline Churton Editor: Diana Vowles Designer: Clare Baggaley Photographer: Laura Wickenden

A video, Watercolour Landscapes from Photographs, is available from APV Films, 6 Alexandra Square, Chipping Norton, Oxfordshire OX7 5HL

The Prism image projector, produced by Artograph, shown on p. 15 is available from Daler-Rowney Ltd, P. O. Box 10, Bracknell, Berkshire RG12 4ST; the Kopykake overhead projector shown on p. 15 is available from Teaching Art, P. O. Box 50, Westborough, Newark, Nottinghamshire NG23 5HJ.

ISBN 0 00 712166 0

Set in Plantin and Franklin Gothic Colour origination by Colourscan, Singapore Printed in China by Imago

PAGE 1 Afternoon Sunshine, 30 x 40.5 cm (12 x 16 in)

PAGES 2 and 3 Greek Beach, 30 x 40.5 cm (12 x 16 in)

DEDICATION

This book is dedicated to my friend Dr Don Fisher, a man of great humour. Not content with finding my lost hake brush in the middle of the Oregon wilderness, he went on to find for me a wife, my lovely Darlis.

ACKNOWLEDGEMENTS

First I must acknowledge the immense help and patience of my assistant Ann Mills in the production of this book. My dear wife Darlis has typed every word of copy and caption, and many of the photographs have been lent by Dr Don Fisher of Oregon. For all these things, I am extremely grateful. Introduction page 6

Equipment page 12

Composing Your Photographs page 16

Composition and Design page 22

The Tonal Sketch page 32

Projects: Skies page 50

Trees and Woodland page 52

Projects: Trees and

Woodland page **64**

Water page 66

Projects: Water page 78

Flowers page 80

Projects: Flowers page 86

Figures in the Landscape page 88

Projects: Figures in the

Landscape page **94**

Buildings page 96

Projects: Buildings page 104

The Four Seasons page 106

Gallery page 116

Index page 128

	BW RY S	M SERVIC	ES
MMAI	19	METO	
MWIN		METW	
MASC		MOLD	
МООО	200	MSUN	10/01
MDAT		MOON	
MDED			

INTRODUCTION

One of the most controversial topics in painting is whether or not it is acceptable to work from photographs. This subject seems to

generate more words in art magazines than any other, cropping up time and time again in editorials, letters and articles. Even in art societies it is a matter of constant debate.

USING NEW TOOLS

It seems to me that there is often an element of hypocrisy present in the 'against' lobby. Doesn't it seem strange that in other fields of art such as music this kind of controversy appears not to exist? The use of a computer in the composition of music is apparently quite acceptable, for example. What the composer has done in addition to using his or her musical skills is to take the trouble to learn the use of new technology in the search for excellence. The situation is similar in art. The camera can be employed as an extra tool, a tool like any other, the best use of which has to be learned. What the 'against' lobby seem to forget is that you have first to become a competent painter, skilled in all areas of your art, before you can use photography successfully as a tool. The purpose of this book is to look at the whole subject honestly and to illustrate some of the exciting possibilities that

are offered by working with this extra piece of equipment. I hope that the illustrations used in this book will convince you of the truth of my conviction that photographs can be a great boon to the artist.

EXTRA SKILLS

Perhaps it will help my case if we take a quick look at some of the statements that are made against the use of the camera in watercolour painting: 'It's cheating.' 'It's a short cut, avoiding the need to learn drawing and sketching.' 'It's taking an easy option.'

None of these is true: to bring a scene in a photograph to life in watercolour needs all the skill of which an artist is capable. In fact, there is an extra skill involved, which is of course using your camera with competence - employing all your design skills, but this time through a viewfinder. Any serious photographer will tell you that photography is an art in its own right and of course this is true, but it can also be used as a stage in the process of watercolour painting. Nevertheless, I do still feel that to produce the best paintings the artist must have been out there in all

weather, surrounded by the atmosphere and even the smells of a location, before he or she can exploit this extra and controversial tool.

As a teacher, I'm shown thousands of photographs each year, 75 per cent of

Tumbling Water. Oregon. 35.5 x 28 cm (14 x 11 in)

The aim in this picture of an Oregon river was to create a feeling of harmony, and this was achieved by keeping all the colours to one side of the colour wheel. The main object of interest is the white water, which I've restricted to one fall rather than the two that existed. I've used strong directional strokes of the hake to give more movement. The colour of the lefthand foreground is echoed in the background trees, introducing a note of unity into the design.

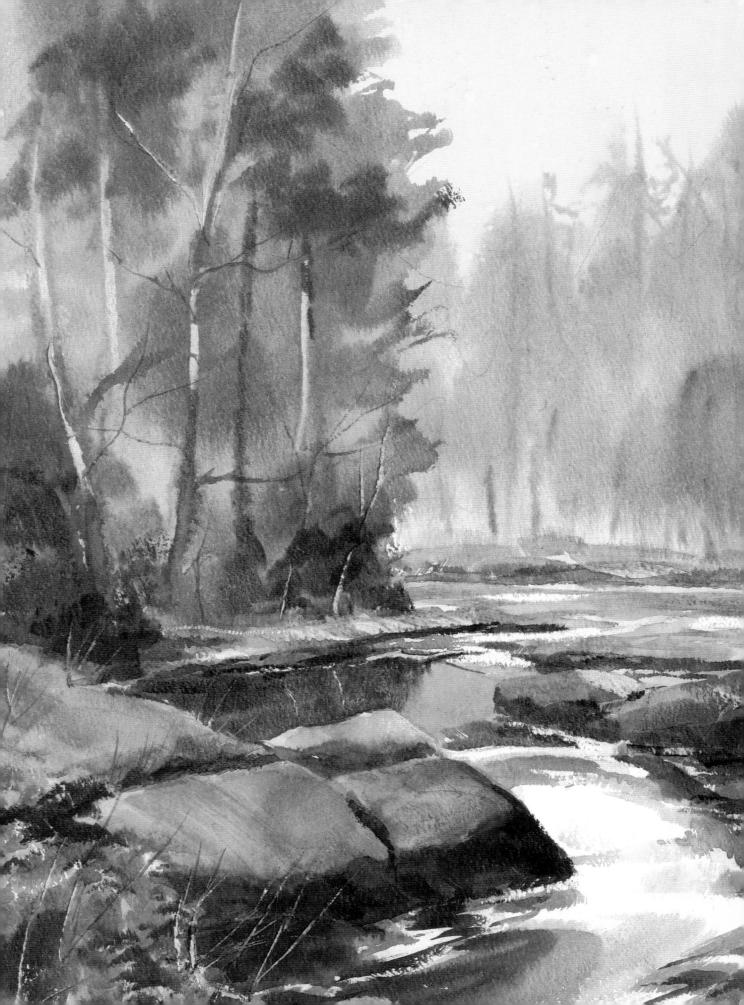

which are badly composed and uninspiring. But the worst results of painting from photographs come from the artist who attempts an exact copy of the photograph complete in every detail, warts and all, with little or no sign of the artist's own personality and flair.

THE CAMERA AS AN AID

Let us look now at some examples of where the camera is most helpful. One is a crowded street scene in a city – a lively and inspiring subject, but it is almost impossible for most of us to set up our easels on a busy pavement or in the middle of the street. However, a quick sketch and a few good photographs will be invaluable to give you all the information to form your picture and interpret the scene in your own style back in the studio.

Another example might be a wet, misty day in the mountains. It would be extremely difficult to paint in watercolour in these conditions, but equipped with a good photographic record you will be able to produce an exciting result at a later date. You can also photograph some of the more transient weather effects, such as a sunset that may last only a few minutes or a rainbow that could be gone in only seconds.

I am sure the stalwarts among you will feel that any additional difficulties are a necessary part of painting, but to be realistic the vast majority of artists are simply not always able to paint on location. Among my own friends who are

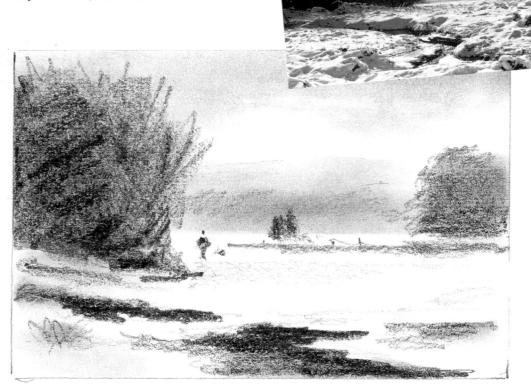

8 WATERCOLOUR LANDSCAPES FROM PHOTOGRAPHS

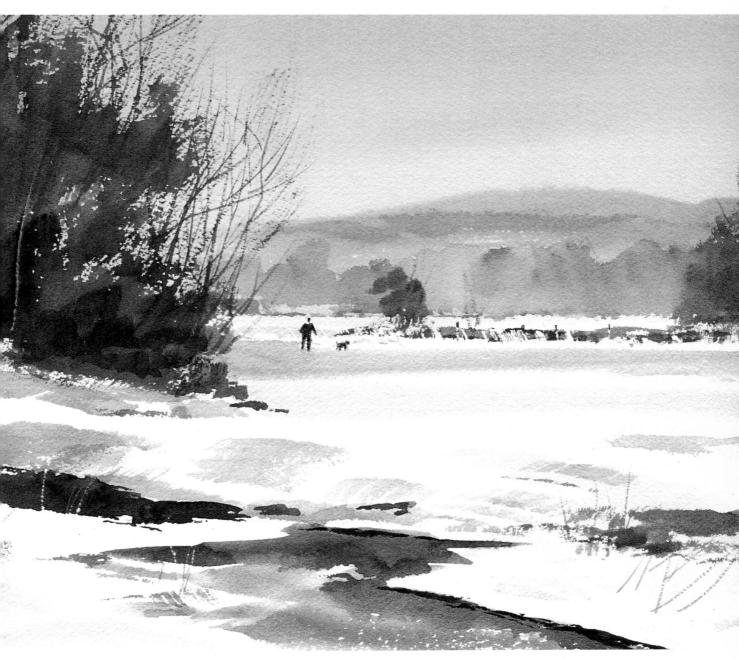

Sun on Snow, Oregon, 30 x 40.5 cm (12 x 16 in)

This watercolour is based on a photograph I took in Oregon, USA. Before starting to paint I made a tonal sketch (opposite) in which much of the surface of the snow has been smoothed out and more prominence given to the

foreground stream. I reduced the mass of trees on the left to improve the balance of the scene and introduced the figure with the dog to provide a focal point. Much of the snow is untouched white paper. I employed only the hake and the rigger in this painting, using the latter for the figure, grasses and twigs.

professional and respected artists some still prefer to work outside all the time, but most have discovered the advantages of the camera after many years of working in the field. The paintings of both groups are as sought after as ever and I would defy anyone to know which were done on site and which were based on photographic reference. I still love to work on site, but I see no need to apologize for using a camera at those times when it is most valuable.

PHOTOGRAPHS AS INSPIRATION

Shortly before writing this book I returned from a round-the-world painting and teaching trip, during which nearly all my on-site paintings were sold. However, I brought back hundreds of photographs from places as diverse as California, Australia, New Zealand and Thailand, many of subjects I had already painted on site. Looking at the photographs not only brought back with clarity the atmosphere of the various locations but also inspired me to produce more watercolours as a record of my trip – many of which appear in this book.

My own loose and impressionistic

style is well suited to interpreting

photographs as the painting will leave a certain amount to the imagination of the viewer – something a photograph cannot do. It is the entirety of the information within a photograph that can give a flat, static appearance to a painting, and it is the job of the artist to bring back the excitement and mystery of a subject and to create a

relationship between artist, subject and viewer in which the viewer has to exert his or her own thought and imagination to complete the circle.

It can be seen, then, that using a camera is no easy option: first you must learn both its potential and its limitations, and once you have taken a well-composed photograph you will need additional skills to interpret it in a professional way.

PRACTICAL PROJECTS

To help you make a start at painting from photographs I have included a number of projects in the book. Each features three photographs that you can use as the basis for paintings. You will find my own interpretations of these photographs in the Gallery at the end of the book.

MAXIMIZING THE USE OF THE CAMERA

My reason for writing this book is to help you avoid the drawbacks of using the camera in watercolour and maximize its benefits to the full. The key to the subject is the realization that the photograph is merely a reference: you must interpret it to change the scene from one that would be static and flat as a painting

to one that is filled with the

qualities that attracted you to the subject in the first place. This exercise requires sensitivity, imagination and skill, as well as the understanding that you have a demanding and challenging task ahead. With the help of this book, accept the challenge and add a whole new dimension to your view of watercolour painting.

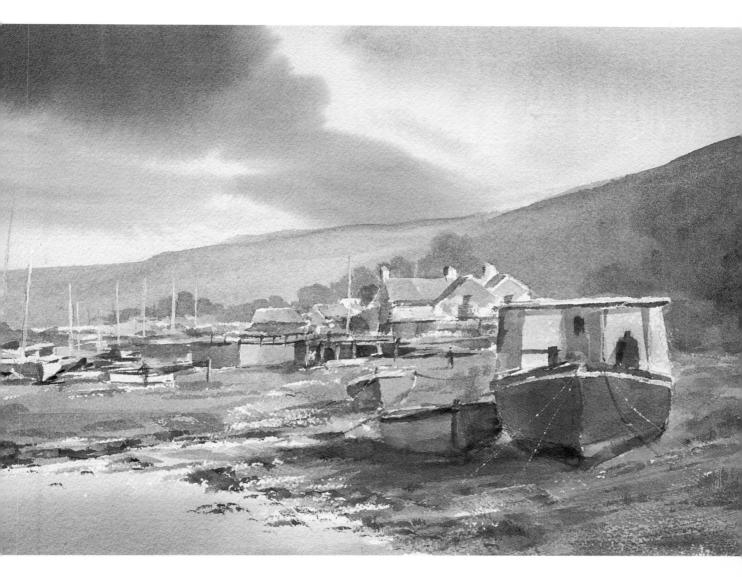

Porlock Weir, 25.5 x 35.5 cm (10 x 14 in)

The photograph, while on the whole satisfactory, is slightly weight-heavy on the right-hand side and I corrected this in the painting by putting in a fairly rich cloud formation top left to provide balance. I've tried to repeat the touches of colour throughout — even the red of the gas cylinder on the deck of the foreground boat is repeated

in the group of boats on the left. I felt that the house on the right edge was an unnecessary distraction. Note the variety of colour in the right-hand foreground and the use of dry brush for the pebbles at the edge of the water. I've simplified and counterchanged some of the background buildings and used gouache to obtain the white masts. I've also added a couple of figures to complete this friendly scene.

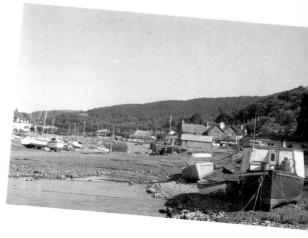

EQUIPMENT

The equipment you will require to paint watercolours from photographs need not be pricy. Simplest of all is to have an inexpensive camera which will supply you with colour prints from which to make a tonal sketch. You can then draw the image on to watercolour paper before beginning to paint. If you're employing this method

it may be best to draw first on to tracing paper, scribble on the back with soft pencil, then transfer the image to your watercolour paper to avoid spoiling the surface of your paper by rubbing out mistakes. At the other end of the scale, you can use some of the specialized equipment shown in this chapter.

My sketching materials include soft pencils, graphite sticks, graphite pencils and sticks of charcoal. A ringbound sketchbook and a putty eraser complete the kit.

SKETCHING MATERIALS

The pencils you use for making a tonal sketch must be soft – from 2B to 6B. Flat graphite sticks and solid graphite pencils are very good as they will prohibit you from putting in too much unnecessary detail and will also produce areas of tone more quickly, as you can use the sides. Sticks of

charcoal are an alternative, but they are fragile and smudge easily. Make your sketch on a pad of ordinary cartridge paper – watercolour paper is not suitable, unless you want to do your tonal sketches in watercolour as I sometimes do, using Burnt Umber or Payne's Grey. A putty rubber will also be useful to pick out the whites.

Here you can see my four brushes the 38 mm (1½ in) hake, the 25 mm (1 in) flat, the No. 3 rigger and the French polisher's mop and my seven favourite colours. These are Lemon Yellow, Raw Sienna, Burnt Umber, Crimson Alizarin, Light Red. French Ultramarine and Payne's Grey.

WATERCOLOUR MATERIALS

While you can use whichever brushes suit you, I feel large brushes are best as they prevent the precise copying of photographs which has given the process a bad name. The only small brush I use is the rigger, which is great for fine details. Everything else is done with a flat, a hake and a

French polisher's mop – big brushes that prevent me overworking.

The range of colours is a matter of choice. I prefer to work from a limited palette, using large tubes of paint and a large plastic tray to mix them on. Most of my painting is done on pads of Bockingford paper or blocks of Arches Cold Pressed.

A corner of my studio, showing some of my photographic equipment and my slide projector.

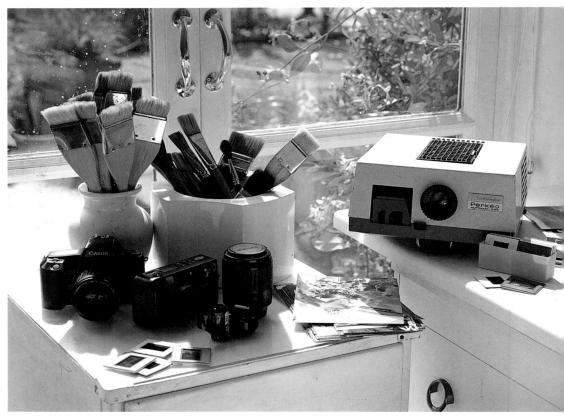

CAMERAS

My view is that a camera should be simple to use and light to carry. The one I use most is a single lens reflex (SLR) camera. Most are now automatic and do nearly all the work for you, except of course for the composing – of which more later. I also have two extra lenses – a wideangle lens which reduces scale and widens the field of vision and a zoom lens to bring distant objects nearer. You may also find a tripod useful for low light levels when the shutter speed drops below an acceptable figure for hand-held photography.

You do not need to spend a lot of money on a camera – most produce quite acceptable results, and a good photograph depends more upon the artistry of the photographer than the quality of the equipment.

TRANSFERRING THE IMAGE

Transparencies are usually on 35mm film and so they will need to be enlarged. One way of doing this is to put them in a projector focused on a light wall in a darkened room. The image can then be drawn on to white paper. The size of the enlargement will depend upon the distance of the projector from the wall. Alternatively, you can now have excellent prints made from your transparencies by laser copier, a service available from most local printers and libraries.

PRINTS

The simplest and best method of using a print is to hold it in your left hand while you draw with your right. This isn't always as easy as it sounds, especially if the scene is a complex one; whatever else you're going to do

with the scene, your drawing is obviously going to be an enlarged version of it, incorporating all your compositional changes.

The traditional way to establish the correct proportions is to place your photograph in a corner of the paper, joining the opposite corner with a diagonal line and extending this line onto the paper. The proportions of the enlargement will be correct if the corner is placed at any point along the diagonal line.

Another method is to photocopy the print, enlarging it to the required size. This can be used as a guide to making your drawing on cartridge paper. You'll then need a sheet of transfer paper, which can be bought at any art shop. This is thin tissue, coated on one side with graphite. Failing this, you could simply rub soft pencil over the back of your drawing, then trace through onto the

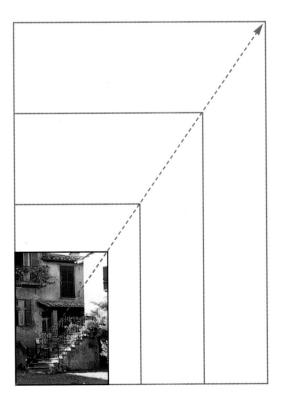

watercolour paper with a ballpoint pen. This will save making too many alterations on the watercolour paper. A third alternative is to use one of the projectors available which will enlarge the print for you.

However, with all these aids there comes the temptation to produce tight, overworked drawings which could then reflect in your finished painting, especially in such subjects as flowers, foliage and skies. Like the photographs, such equipment must be your servant and not your master. Try constantly to improve your skills in freehand drawing and as you progress you may find you only need to use special equipment as a timesaver on occasions when you are producing really complex subjects. Never use equipment of this kind as a crutch in order to avoid learning to draw. After all, virtually every photograph will need considerable changes made to it if you're to produce a satisfactory painting.

The traditional way of scaling up a photograph is to put it in one corner of the paper and then draw a diagonal line to the opposite corner.

The Prism horizontal image projector, which can enlarge the original × 20.

The Kopykake overhead projector for prints.

COMPOSING YOUR PHOTOGRAPHS

The photographs you use for reference in your watercolour paintings need to be the best you can obtain, so in this chapter we are going to look at ways to improve your photography. It's a

sad fact that many photographs taken today, even with all the technical help available from modern cameras, are simply no use at all to paint from. The missing ingredient is composition. Even highly skilled watercolourists who regularly practise the principles of composition in their paintings don't seem to be able to relate them to photography, while in any twenty prints shown to me by my students, perhaps only two or three will be suitable for use as reference material. A good, well-composed photograph will make you want to reach for your brushes.

THE BASIC RULES

Perhaps the most basic rule is simply this: always try to have three planes in your photograph – foreground, middle distance and far distance.

Look at the same view from different angles, as what may look breathtaking

seen from the top of a hill may be boring as a print. While the middle and far distance are usually in evidence, a suitable foreground object is often missing. Be patient and move around until you find one that satisfies you – it

may be a tree, a gate, or even a gatepost. Look through your viewfinder and make sure that you have all three planes in view; if you haven't, don't press the shutter.

For example, you might be considering a beach scene with two boats of similar size. What you need to avoid here is taking the shot with the boats at either side of your photograph. Instead, move around until vour viewfinder shows you a picture in which one boat dominates in the foreground (the scene could be even more interesting if the boats overlap). If you're photographing a wood, rather than just taking a general view, find a position where you have one tree, perhaps of a different species from the mass, prominent in the foreground.

PROVIDING A LEAD-IN

Try to find a feature that will lead the viewer's eye into your photograph – a footpath, a cart track or a stream. Look for interesting close-ups, and remember that you don't always need bright sunshine; misty and cloudy conditions can sometimes be more interesting. Try the view both horizontally and vertically. Practise

without a film in your camera, concentrating entirely on composing what you see through your viewfinder. An hour or two spent in this way will be invaluable, and you'll soon begin to understand the difference

Waterfall Near Glencoe, (detail)

This loose interpretation is from a photograph I took in Glencoe. It is painted very much wet-intowet, vet at the same time I tried to put in as much rich, powerful colour as I could hence the almost purple rocks in the foreground. There is a very strong but simple pattern here, with the maximum contrast being confined to the foreground water and rocks.

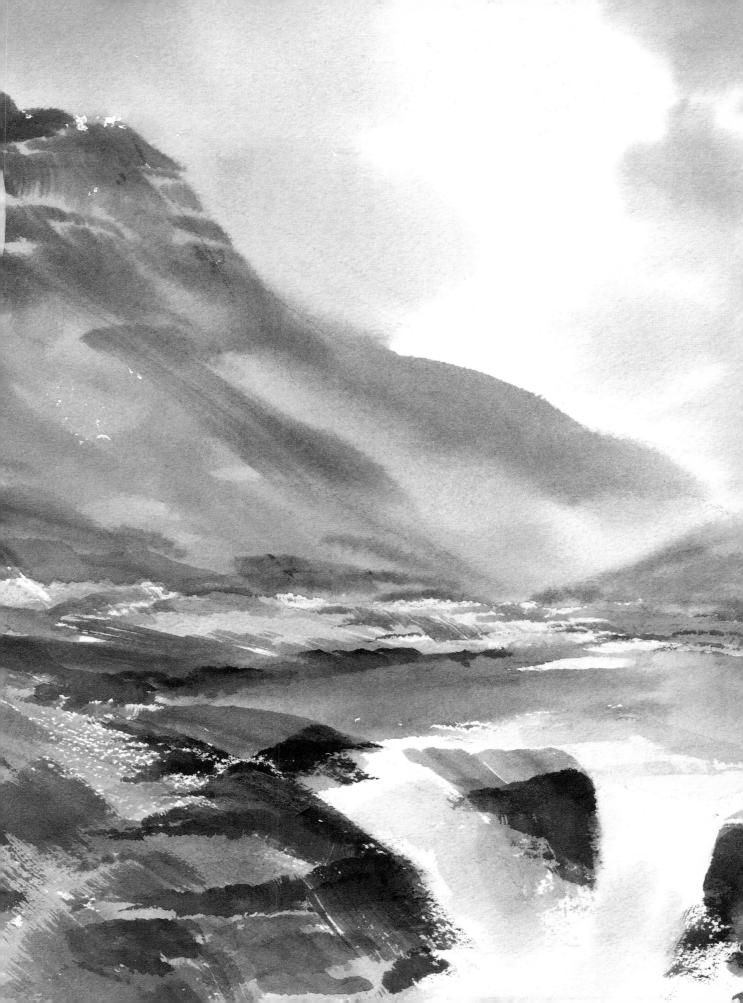

between a good composition and a poor one.

No matter how much time you take over your photographs, chances are that once you have had your prints processed you will need to do some careful editing. Look at each print critically, considering the tonal values, the depth of field, and whether there are conflicting centres

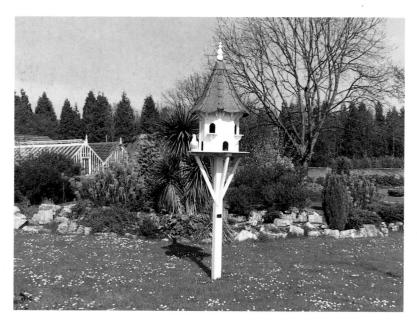

▲ Here the main object of interest, the dovecote, is right in the centre – possibly one of the worst compositional faults. This stricture applies to any focus of interest, whether it be a boat, house, bridge, person or animal.

► In this photograph the dovecote has been moved to one side, immediately making the composition more satisfying. of interest, with too many objects all vying for your attention.

A good way to assess the prints is to take two L-shaped pieces of paper, overlap them to make a picture shape and then move them around until you are focusing on the heart of the scene. You will probably find that you are looking at the very thing that attracted you to that particular view in the first place. Quite often, a photograph with which you are initially disappointed will look far more interesting once all the clutter is removed; a horizontal may become a vertical, or a boat that was facing out of the photograph may face inwards with judicial manipulation of your L-shapes.

Many of the skills involved in photography and painting are so closely linked as to be interchangeable. Becoming a good photographer will improve your painting, and vice versa. So much depends on good design and composition – and this principle applies equally to both photography and painting.

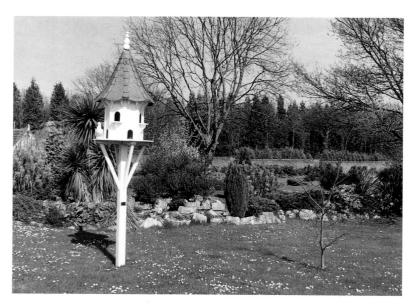

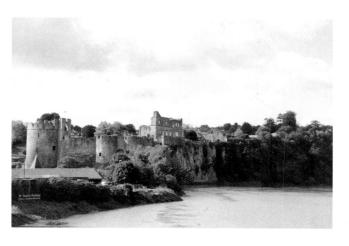

■ This is a conventional view of Chepstow Castle. It could be used as the basis for a painting, but would need a lot of preparatory work in the tonal sketch. The sky and the river are much too bland, and the whole scene is lacking in drama.

Another approach is shown here, using a foreground boat and bank. This view hasn't quite worked as a composition, however, because the boat and the castle compete with each other.

■ This photograph introduces a vertical element into the picture, linking the two banks of the river, but the foreground foliage is too dominant, blocking the entrance into the picture.

This view of the castle is very satisfying. The strong vertical element of the tree in the foreground balances the castle wall and takes the eye directly towards it.

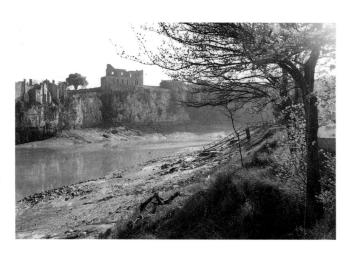

▼ Finally, I decided to use this portrait photograph as the basis for the painting. I felt that this framing of the shot made the massive bulk of the castle look more dramatic.

► I felt that the photograph was bottom-heavy, so in the tonal sketch I discarded part of the foreground and enlarged the sky. I also moved the mass of the trees slightly to the right to avoid masking the castle.

Chepstow Castle, 40.5 x 30 cm (16 x 12 in)

In the painting I aimed to get a much greater variation in colour than was apparent in the photograph. I lightened the river to make the tonal value more distinct from that of the foreground bank and warmed up the scene with pinks and mauves. I also painted in a more interesting sky, with the blue interspersed with clouds.

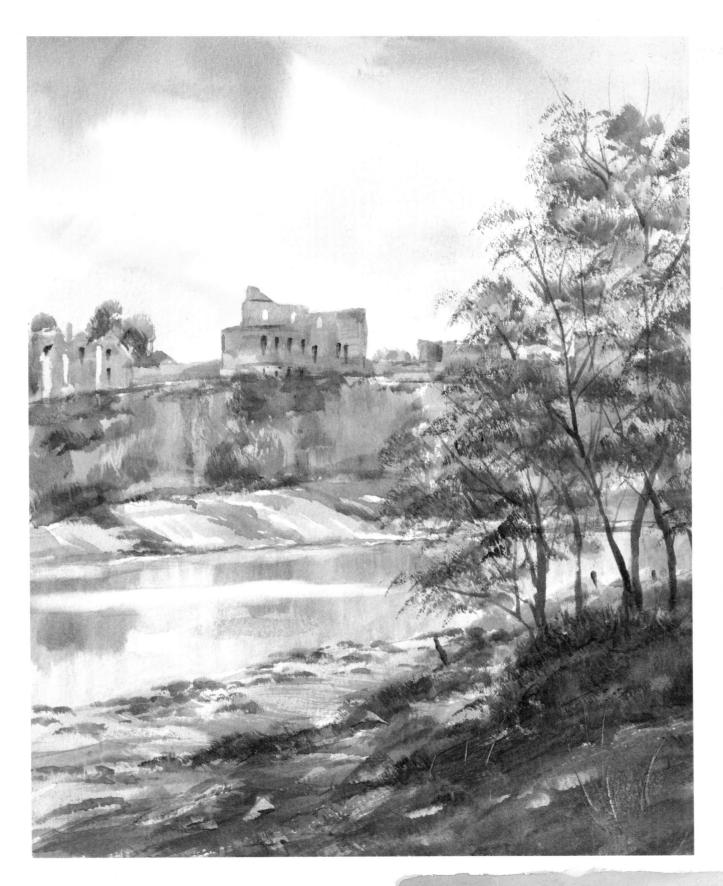

COMPOSITION AND DESIGN

If you have followed the advice in the previous chapter you will now be producing photographs that are reasonably well balanced, containing a main object of interest and encompassing foreground,

middle distance and far distance. So at least now you have a good starting point – and you should be itching to paint, to capture those vital elements that stopped you in your tracks in the first place. Before you can convert the photograph into a painting of lasting worth, however, there is a lot more work to do.

COMPOSING YOUR PAINTING

The previous chapter discussed the composition of your photograph, but even the most perfectly composed photograph will not translate directly into a well-composed painting. Composing through a viewfinder and composing a finished painting are by the very nature of things slightly different exercises.

For example, although your photograph will have a main object of interest, it may be necessary to change a path, a road, or the sweep of a river to take the viewer's eye into the picture and on to the centre of interest. There may be a boat or a figure facing out of the picture which will need to be reversed or moved to avoid the viewer's eye being taken out of the picture rather than captured within it. Foreground walls or fences in your photograph may

require removal or opening up – after all, you don't want to fence your viewer out! The composition may be vastly improved by adding a foreground shadow that is not on the photograph; on the other hand some shadows may need to be lightened and made more transparent. Always avoid placing the horizon in the centre of your painting, as this would cut the picture in half. Think carefully too about the positioning of the centre of interest, which should be a different distance from each edge of the painting.

THE PRINCIPLES OF DESIGN

More specific rules for composition can be defined by considering the principles of design. These are not complicated and in fact most are just common sense, but they will improve your work dramatically; your knowledge or ignorance of them will be evidenced in every painting you produce.

There are only eight principles of design to memorize, and they are: contrast, dominance, unity, graduation, balance, harmony, variation and alternation. It is easy enough to learn this list by heart – the difficult bit is applying it to each painting. It is not necessarily possible to apply every rule to every painting, but the more you are able to put into practice the better your painting

will be.

Grounded, 35.5 x 28 cm (14 x 11 in)

For the last 13 years I've been running workshops in this tiny lobster-fishing village on the coast of Maine. This harbour scene has one of the lobster boats as its main object of interest, so this has been placed at a different distance from each edge of the page. It has been made to stand out by darkening the area immediately around it. You will also notice that the boat is not challenged by anything else in the picture that might distract the viewer's eye.

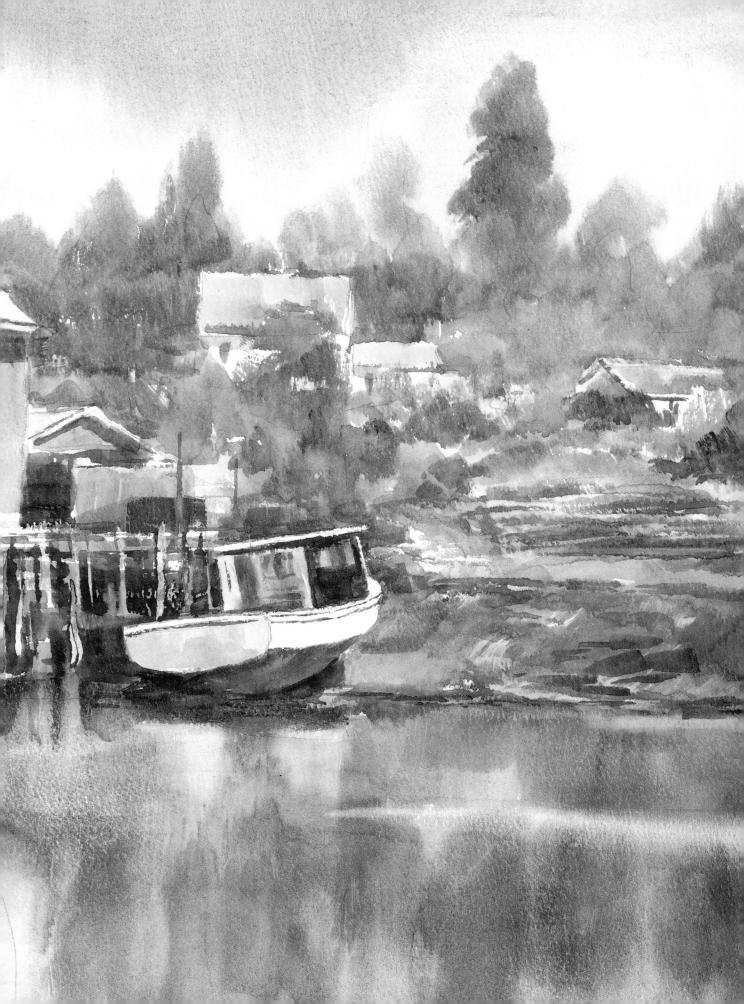

CONTRAST

Contrast is an abrupt change from one state to another: warm to cool, light to dark, hard to soft. When you are working with photographs you will often find that you have to increase the contrast in the areas to which you want to attract the eye and decrease it in less important areas.

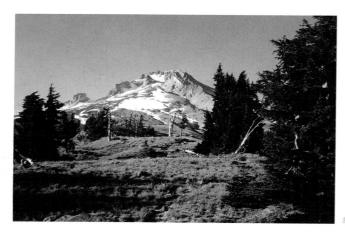

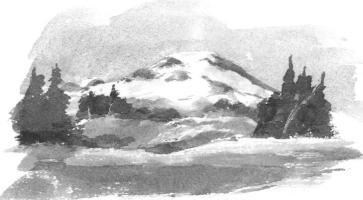

In the photograph the patch of white snow makes a good contrast with the dark trees, and the hard outline of the mountain contrasts with the softer texture of the trees and grass. Even the white dead trees provide contrast.

The contrast between snow and trees was sufficiently strong for me to be able to lighten the green somewhat in the watercolour. However, I have darkened some of the rock face to provide stronger contrast with the white of the snow.

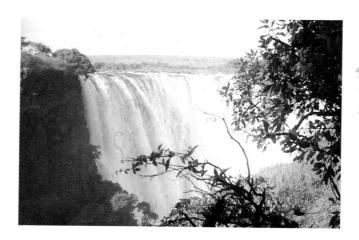

I took this photograph because I wanted to record the dark, clean-edged foliage against the soft white foam of the falls. The colour contrast is good, too, with the light grass showing up well against the dark twigs and leaves.

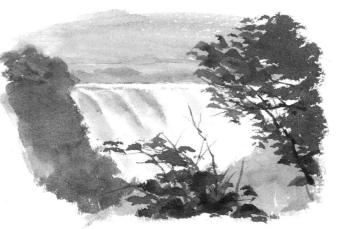

When it came to painting the scene I decided to lighten the foliage on the right and on the side of the falls to the left to give more harmony of colour, but there is still plenty of contrast between the white foam and the surrounding vegetation.

DOMINANCE

My feeling is that this is probably the most important principle of all. What it means is that in any painting, one object must be more important than any other. To achieve this you can make that object larger, brighter, the area of greatest contrast, or even a combination of these elements. If a dominant feature is not evident in your photograph you must ensure that it is provided in your tonal sketch. For example, if you have three mountain peaks or three clouds of the same size, you will need to make some changes to give one dominance.

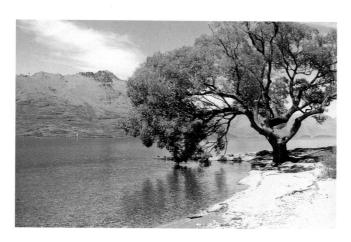

This photograph was taken at an angle that gave the foreground tree dominance over the mountains. In fact, the tree is perhaps too dominant, leaving the rest of the scene as just a backdrop.

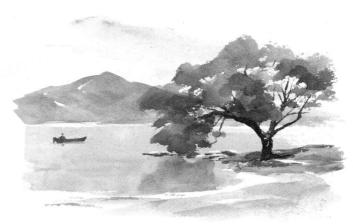

In the painting I added a small boat which corrects the imbalance of the photograph. The sweep of the beach and the rocks lead the viewer's eye into the picture and to the boat.

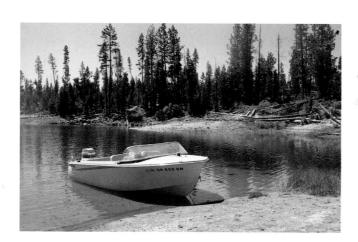

There can be no doubt at all about the dominant object here – the boat is a manmade object, which always draws the eye. The rest of the picture acts simply as a background for the boat.

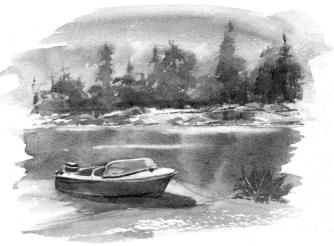

I needed to change the design little for the painting other than to broaden the stretch of water showing behind the boat in order to allow more depth of field into the scene.

UNITY

Unity is an interlocking of all the elements in a painting. While your photograph may show a collection of disparate objects, as is often the nature of things, your job as an artist is to unite these elements in your tonal sketch before you start your painting. Overlapping is useful here, or you could echo shapes or colours. Have a close look at the illustrations here and see how I have used this principle.

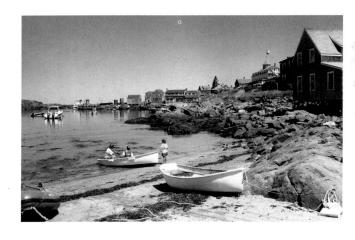

This was an attractive scene to photograph but it had too many scattered objects in it – the viewer's eye is distracted by disparate shapes and colours.

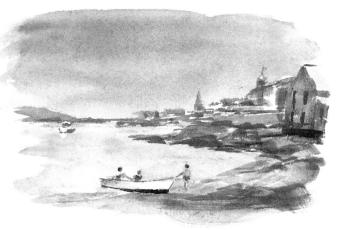

In the painting I created unity by removing some of the objects and concentrating on a single boat. The sweep of the beach is a good unifying factor, as is the echoing of the yellow of the life jacket elsewhere in the picture.

In this photograph there are plenty of soft brown and ochre colours in the grasses, foliage and house roofs to provide unity of colour. The white of the small sailing boat is also echoed in the white of the row of houses.

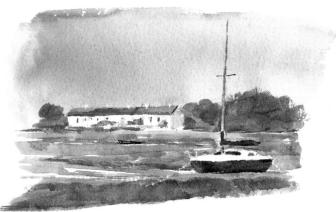

Repeating the whites worked well here, and I also included white in the water for emphasis. The mast is a useful unifying factor linking earth to sky. The colours in the roofs are echoed in the foreground grasses, as is the sky colour in the water.

GRADUATION

This technique is employed to avoid boredom in a flat area. It is the gradual change from one state to another: light to dark, or cool to warm. Photographs often lack this quality, especially in the foreground, and in this case it is probably better to ignore what is in the photograph and put in your own graduated wash. An area where this technique is often needed is in the portrayal of a row of buildings, where making changes in the wall surfaces will avoid a flat, dull appearance.

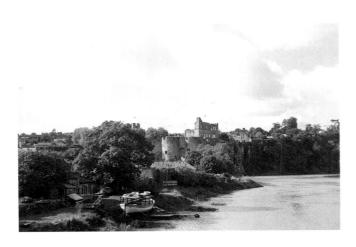

Here the photograph shows a rather solid bank of flat greens in the background trees and the expanse of water is somewhat boring.

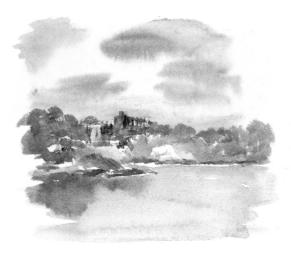

In the painting I have graduated the greens in the trees and the browns and greys in the water to add interest to what could otherwise be a dull painting.

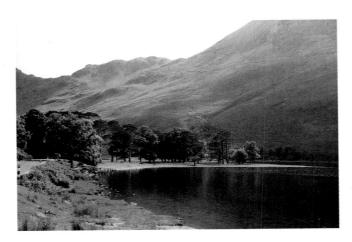

Here the subtle tones of the mountains of the English Lake District reflected in the water below make a pleasing photograph, but if they were translated directly into a painting it would lack depth and interest.

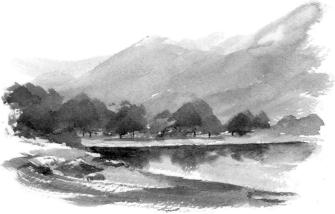

In the painting I've graduated the greens from cool to warm as they come forward, repeating this in the reflections. You will also notice graduation in tone in the trees from dark to light, as well as in the colours of the foreshore.

BALANCE

Balance is an important element in a composition. Any large object in a scene has a tendency to unbalance it, but this can be corrected by moving it nearer to the centre and balancing it with a smaller object further away on the other side. Think of a seesaw; if you have a heavy weight on one side of the seesaw, it can be balanced by a lighter weight further away from the centre. While you could have equal weights on both sides, this would be far less interesting visually.

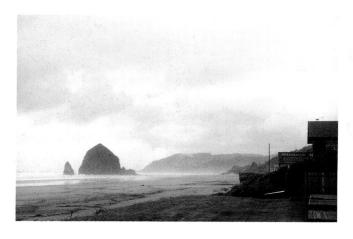

When I took this photograph I aimed to balance the vertical bulk of the large rock just offshore with the horizontal expanse of sandy beach nearer to the camera.

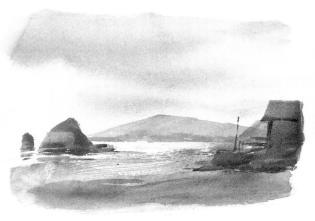

Nevertheless, the painting is about the rock, so I have made this a more dominant feature by contrasting it against a lighter sea and sky than appear in the photograph.

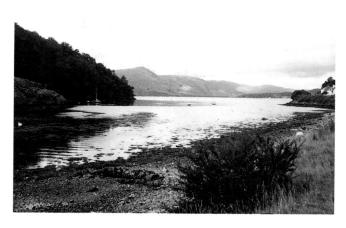

Here I framed the photograph so that the dark foliage of the foreground bush would balance the heavy shape of the promontory on the left-hand side of the picture.

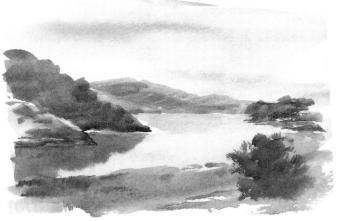

In the photograph the bush almost disappears into the beach, so I've corrected this by changing the tone of the beach and contrasting the top of the bush against the light water.

HARMONY

Harmonious colours are those that are adjacent to each other on the colour wheel, such as orange and red on the warm side and blue and green on the cool. Harmonious shapes are squares and rectangles or circles and ovals. If these elements are lacking in your photograph you will need to create them in your finished painting.

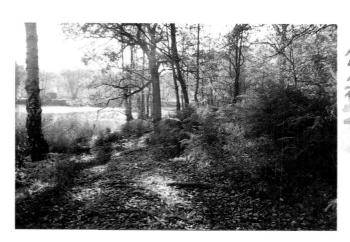

Autumn colours often provide their own natural harmony in a scene, and this is the case in the photograph here. The soft browns, rusts and ochres of dying foliage blend harmoniously with the darker tones of the tree trunks.

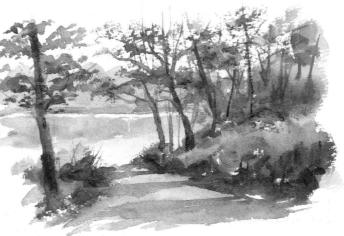

Distant woodland looks very effective when it is painted in a variety of soft, cool mauves, which emphasize the warmth of the browns and oranges used in the foreground and give a feeling of depth to the painting.

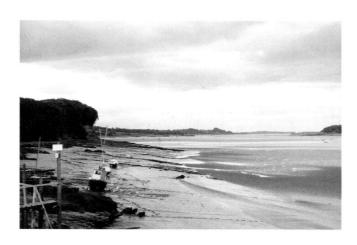

In estuary scenes like this the wet sand reflects the sky colour, giving its own sense of harmony to the scene. If the presence of brightly coloured boats mars the effect, you can simply change their colour in your painting.

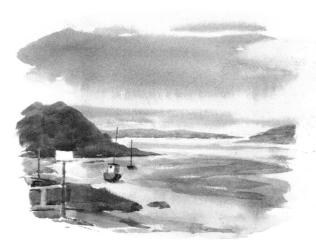

In the painting I have emphasized the existing harmony between sand and sky by using a very restricted palette and applying the colour for the sand with directional brushstrokes to echo the shape of the cloud.

VARIATION

Although repetition may be employed in a painting to great effect, it must be used with variation to avoid monotony. Try to provide variety in repeated shapes or colours. A uniform row of trees in a photograph can be modified in the tonal sketch by varying their sizes, angles, and the distances between them.

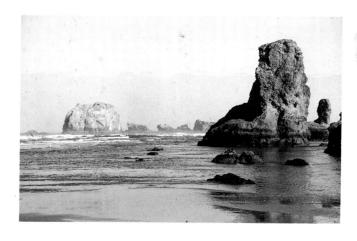

In this photograph there is a good deal of repetition in the waves and the shapes and colours of the rocks. Copied exactly, this scene will not make a successful painting.

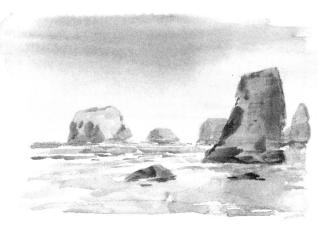

Although repetition is a useful aid in a painting, it must always be done with variation. Here the rocks are more varied in colour, tone, size and spacing than in the photograph.

ALTERNATION

The principle of alternation is most usually applied to colour. It is the placing of intense colour to alternate with neutrals, or warm colours with cool ones.

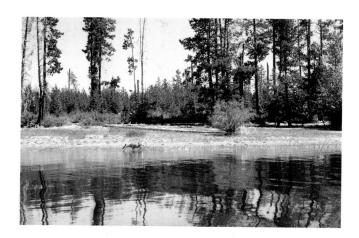

What attracted me to this scene was the reflections of the vegetation and sky in the water. In the photograph there already exists alternation of warm and cool colours.

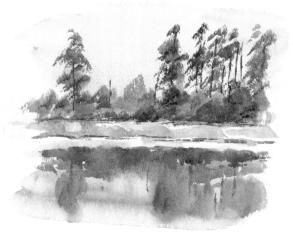

I accentuated the alternation somewhat in the painting, in which warm and cool colours have been alternated from top to bottom and from left to right to avoid monotony.

APPLYING THE PRINCIPLES

It is neither practical nor necessary to include every principle in every painting, but you should habitually test each of your finished paintings against the list of principles to make sure you have not ignored them. It will take time to absorb the principles so completely that you will automatically incorporate them in your painting, so you may find it useful initially to have the list of principles pinned to your board to jog your memory.

In my advanced classes I start by teaching these basic principles, after which we criticize the paintings brought along by each student, judging them strictly by the principles of design. This operation is a real eye-opener for all involved and everyone can see ways in which their paintings could have been improved had they applied the principles. From then on the students' work progresses in leaps and bounds as they learn to use this yardstick.

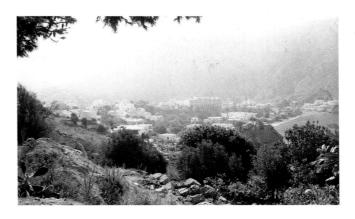

▲ Including overhanging foliage in the very front of a photograph is a classic way of adding interest and depth, but it does not necessarily translate successfully into a painting. The view of the village is rather spoilt by the bushes blocking the nearest part of it, and they also distract the viewer's attention from it. Consequently, this photograph needs some adjustment of composition before it will work well as a painting.

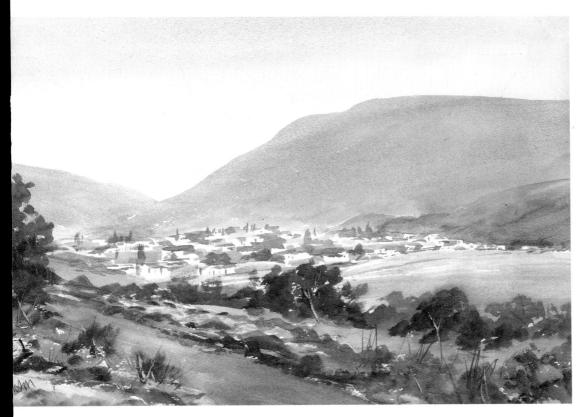

Village on Kalymnos 28.5 x 39.5 cm $(11^{1}/_{4} \times 15^{1}/_{2} \text{ in})$

The centre of interest is the village, rendered with contrasting patches of white and colour. I graduated the hills and sky. The eye is taken into the picture by the path and kept inside it by the tree on the left, which is balanced by strong foreground colour on the right. Unity is provided by repetition of the pinks.

THE TONAL SKETCH

Whether you are painting from photographs or from life, your work begins long before you pick up a brush. A major part of this vitally important 'thinking period' is your tonal sketch.

This is a message that I try to put over to my students at the beginning of a course. They all agree that this is the only sensible way. A couple of hours later, for some inexplicable reason they are ignoring the whole concept – even though they know that no professional artist would ever begin a painting without first working out its tonal values in a tonal sketch. Once I have persuaded my students to produce their tonal sketches I find them attempting to put in every detail, having forgotten that the object of the exercise is to reduce the subject to a simple pattern of lights and darks which probably differs from the original view.

TONAL VALUES

Let us assume that you have never before attempted a tonal sketch. The first thing you need to understand is that tone is simply the darkness or lightness of a colour. Any painting, no matter how colourful or subdued, consists of various tones which form a basic pattern. Tony Couch, a well-known American painter whose work I admire, has said, 'I recall reading and hearing about "tonal values" for years without understanding how to use them. When one day I discovered they are placed in a pattern, it was

as if the sun had just risen: my paintings improved 1,000 per cent.' The stronger this pattern is the more arresting the painting will be, and the time to establish this pattern is in the tonal sketch.

MAKING A TONAL SKETCH

If you are using pencil, get into the habit of varying the amount of pressure, producing different tones from each grade of pencil. Think of a scale from one to ten, with the pure white of the paper being one and solid black being ten. Once you begin to paint, to achieve ten you will need almost pure paint with hardly any water at all, while one on the scale will remain untouched paper. Your sketch pad does not need to be very big as your tonal sketch should only be about 10×7.5 cm $(4 \times 3$ in), but it must be smooth cartridge paper.

Before you start on your first tonal sketch, spend some time doodling on cheap paper with various pencils. As with anything else, you need to be at ease with your materials. Once you have accepted the concept of tonal sketches and had a bit of practice you will find that you are enjoying them in their own right. Take half a dozen photographs and do tonal sketches of them, even if you are not going to take them any further.

That is the accepted way of producing a tonal sketch, but my own favourite method is a little different. This uses watercolour – either

Fjord in Lofoten (detail)

This painting is based on a photograph taken on a trip up the coast of Norway. The far-distant mountain is just one thin wash, but as I moved forward in the picture I introduced more and more texture and colour. The foreground rocks were produced by scraping the paint with a piece of credit card. There is a mixture of warm and cool colour in the right-hand mountain which adds to the general interest of the painting.

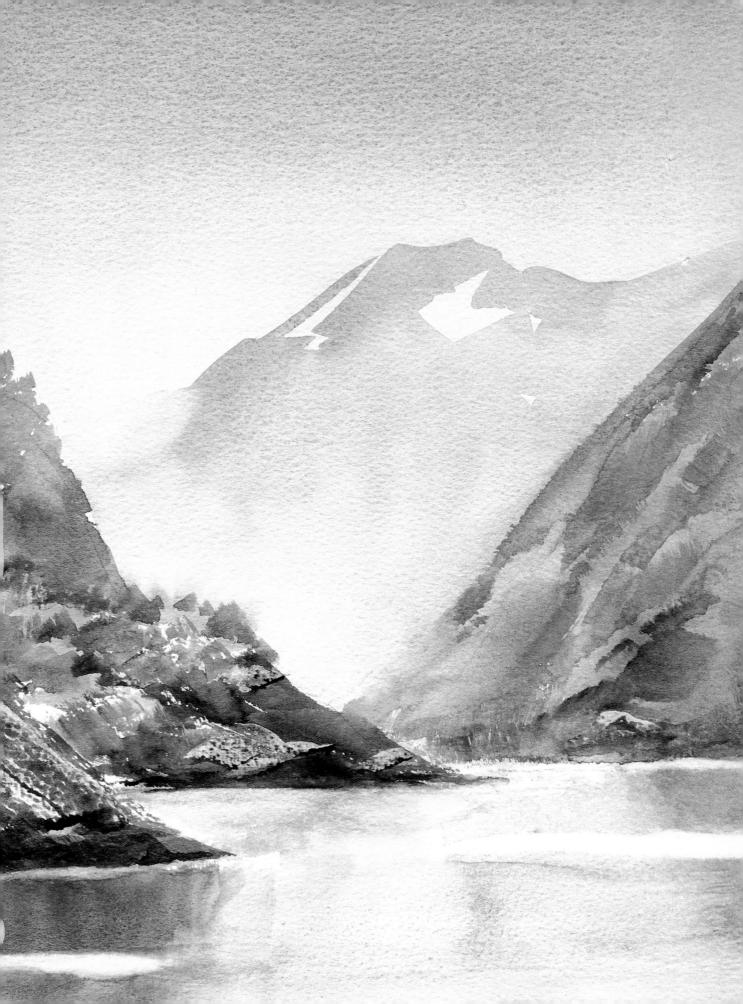

This is a typical example of a tonal sketch done with a soft pencil. The soft tone of the sky was put in by employing a smudging technique with the index

finger, using a piece of white paper as a mask. In the original photograph the tone of the tree and the bridge were too similar and the river was dry.

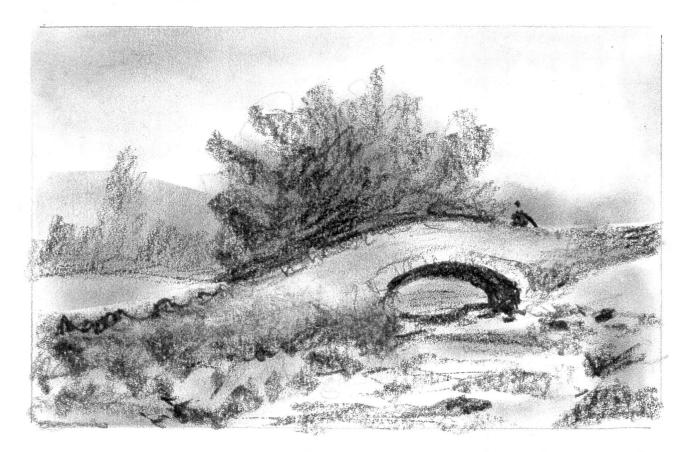

Burnt Umber or Payne's Grey – on scraps of watercolour paper. Like the pencil sketches, I keep them to a maximum of 10×7.5 cm $(4 \times 3 \text{ in})$, and the aim is exactly the same. The only brushes I use are the hake and the 25 mm (1 in) flat, perhaps bringing in the rigger for a figure.

Whichever method you use you must avoid putting in any detail whatsoever, concentrating instead on producing a pattern of lights and darks in miniature. Don't think of the components of your subject as individual objects; see them only as areas of tone. Don't draw lines

around anything as they are not only unnecessary but have no place in a tonal sketch. Confine the white areas of the tonal sketch to those parts of the final painting that will be left as untouched white paper. Every other area should have some tone on it.

As tone is a darkness or lightness of any colour, if you paint a red house against a green tree and the two colours are similar in tone the effect is flat. What is needed is to make the tree a darker green or the house a lighter red so that the painting will read tonally. Exaggerate the darks and lights. Put two on your

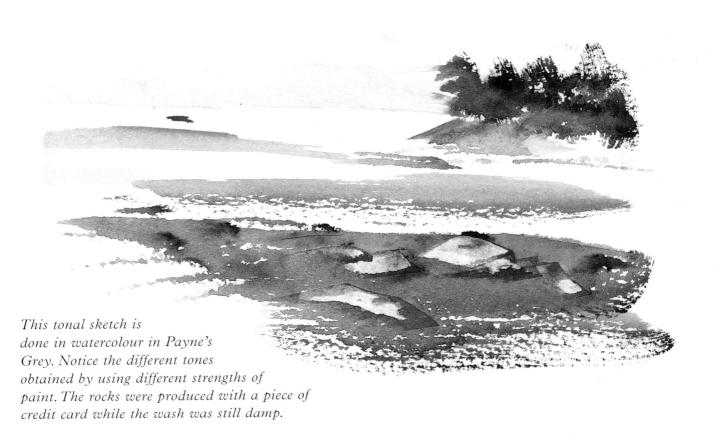

scale against eight, or even one against ten. Remember that you are aiming to produce your subject as a pattern of lights and darks.

AVOIDING PROBLEMS

The most common problems associated with tonal sketches include:

- **1.** Not enough thought. A quote from the late Ed Whitney, one of America's best-known teachers of watercolour, is useful here: 'Design like a tortoise; paint like a hare.'
- **2.** Being in too much of a rush don't neglect that valuable planning or thinking time before you make a mark on the paper.
- **3.** Believing that it's possible to solve all the problems in the final painting;

regard your tonal sketch as an architect would his plan for a new building – it must be right!

4. Failure to follow the tonal sketch in the final painting; keep the sketch pinned above your painting and refer to it constantly. This way you will avoid producing a painting that is a weakened version of what was originally a strong design.

Once you are capable of producing good tonal sketches you will see a marked improvement in your finished painting. By learning to contrast areas of tone you will produce paintings with more sparkle and excitement than you would ever have thought possible.

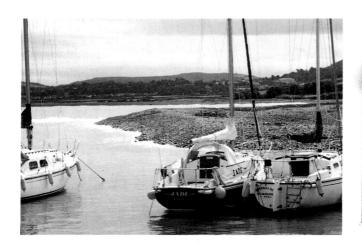

In this photograph of Porlock Weir, the third boat half out of the frame seemed awkward and superfluous. I also thought the hills were too flat.

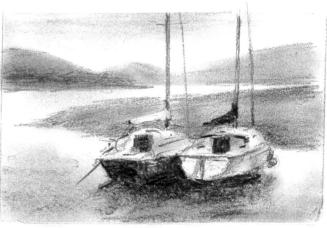

Here I've darkened the left-hand hill to balance the boats and dropped the level of the beach behind the boats to counterchange them against each other. The boats have also been moved slightly towards the centre.

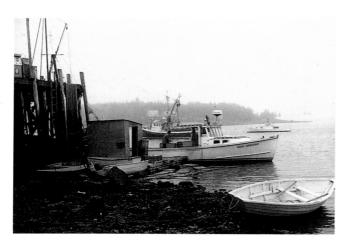

The two foreground boats compete for the viewer's attention in this misty scene in Maine. Also, the rowing boat points out of the picture.

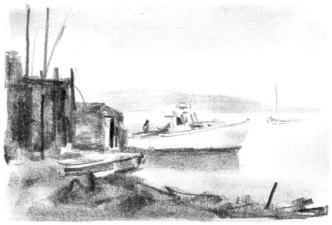

In the tonal sketch I removed the rowing boat and the middle-distance boats, adjusted the rocks and added a distant yacht to help balance the picture.

In this Canadian scene the trees on the left were too dark, attracting the viewer's attention too much. I wanted the trees and rocks on the right to be the dominant feature.

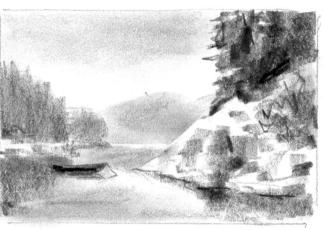

In the tonal sketch I've increased the contrast between trees and rocks, weakened the left-hand trees and added a moored boat to provide a main object of interest. Notice how the foreground rocks point to the boat, which in turn balances the trees on the right.

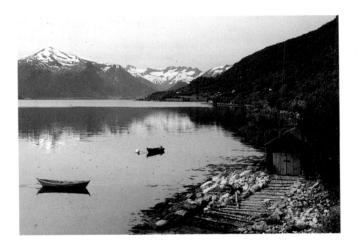

In this Norwegian landscape the boathouse on the right is almost obscured by foliage. It is also dark in tone. The viewer's interest is caught first by the boats and then the snowcapped mountains.

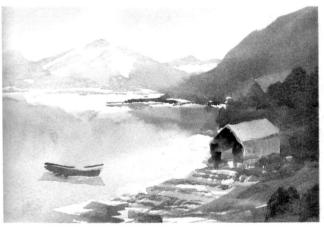

In the watercolour sketch I've counterchanged the boathouse to make it the main object of interest. I have also given more depth to the picture by lightening and cooling the distant mountains.

SKIES

As I drive around the countryside I'm always on the look-out for interesting cloud formations and different colour combinations in the sky. I always try to have my camera with me, but

naturally the best skies appear when my camera has been left at home! Sky conditions and colours change so quickly that they surely strengthen the argument for using the camera as a tool in watercolour painting. For example, you can photograph a racing sky in wild conditions which would flatten your easel in seconds, or in pouring rain that would ruin your painting.

It's not necessary to look for perfect landscape conditions when taking sky photographs because the landscape below will usually be too dark, as the camera's light meter will react to the light in the sky. Conversely, in a landscape photograph the sky often appears almost white because the camera has judged the light needed for the landscape rather than the sky – hence the need for a separate section of photographic reference for skies. Aim for a good selection of skies that you can use with any subject you want to paint.

TRANSFERRING SKIES INTO PAINT

The rule about never attempting to copy exactly from your photograph must be applied even more strictly when you are using a photographic reference for a sky. Your photograph is intended to be simply a visual reminder of what the sky conditions were like. Often you may use only a section of the sky, perhaps providing balance in your picture by making a dominant cloud provide weight on the other side of the painting from a feature in the landscape.

Although I have painted hundreds of skies and can perfectly well produce one out of my head when necessary, I find that looking at a photograph out of the corner of my eye keeps the sky more relevant and authentic. However, anyone looking at the photograph and the painting would probably not see any resemblance between the two.

An important point to remember is that you don't want your sky and foreground to compete, but rather complement each other. For instance, with a low, simple horizon you can really go to town on producing wild, chaotic skies, leaving the foreground completely uncluttered. Conversely, if your subject is a complex street scene or marketplace, your sky will need to be restrained, otherwise the two areas of the picture will conflict.

UNITY WITH THE LAND

To give unity to the whole painting, the sky colour should be repeated in the foreground. This is particularly important where your subject includes water, even if it is just a puddle. If you are using two separate photographs to build up a picture you need to be careful that the

Low Tide on the Severn 35.5 x 30 cm (14 x 12 in)

In this Severn Estuary scene there is good contrast between the soft clouds and the strong textural feel to the foreground. One unifying factor is provided by the repetition of the cloud colour in the water; another is the foreground tree that links the earth to the sky.

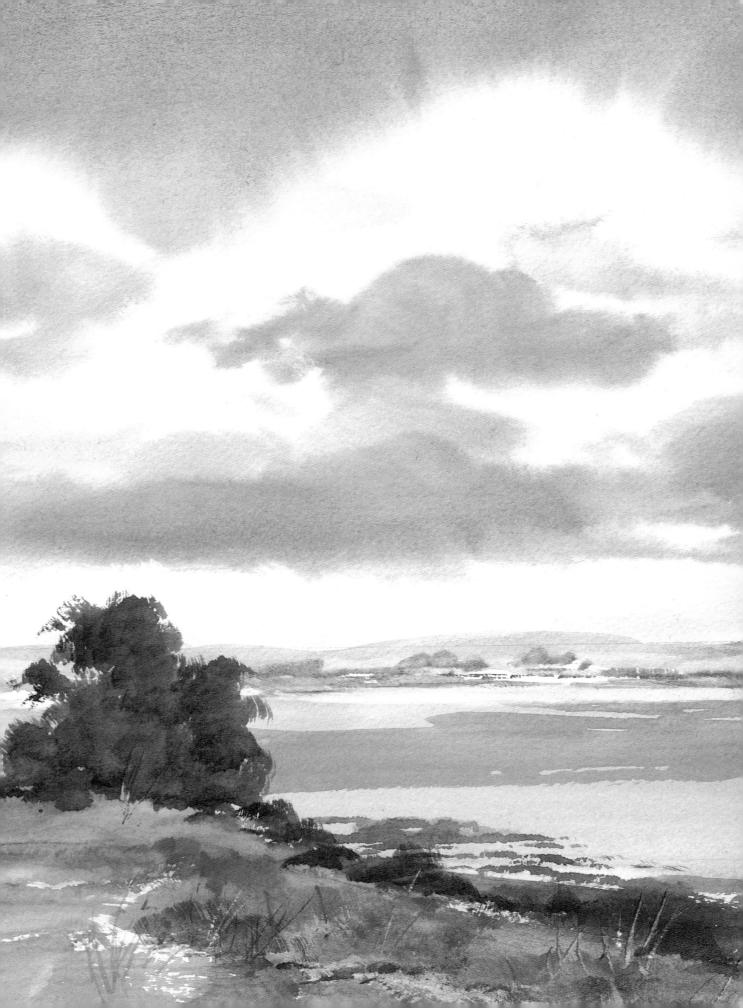

sky conditions predominate – in other words, don't put in shadow if your sky is dull and overcast, but if you have a bright sky with cumulus cloud, cloud shadows should appear in the landscape. This may sound obvious, but I have often seen a painting of a yellow sky with a blue river underneath it!

STUDYING SKIES

Photographing skies will develop the observational skills you need in order to be able to paint them authentically. I am constantly surprised at the lack of knowledge of skies displayed by my students, even though they see them every day. Consulting a more specialized book on the subject will help you enormously, but here is a brief description of the common clouds to set you on your way.

Cirrus clouds are the high, wispy clouds which are sometimes blown into long drifts, forming 'mare's tails'

or creating the light ripples known as 'mackerel skies'.

Cumulus clouds are my favourites. White and fluffy, flat-bottomed and with a cauliflower-shaped top, they are exciting to paint but need practice as well as understanding if they are to be portrayed with authority.

Nimbus are the low, heavy, grey clouds that are often an indication of rain to come.

DESIGN

Let's look now at the actual painting of skies, thinking first about design. Although we've dealt with the subject of design on pages 22–31, there are some principles that are particularly relevant to skies.

I have already mentioned balance and unity; another design rule is to provide contrast of tone, which can be introduced by setting a dark tree against the lighted part of the sky, or

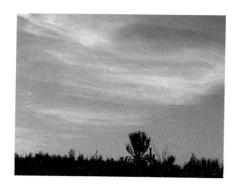

Here is a good example of cirrus clouds, which are commonly known as mare's tails. These can be used in an otherwise plain sky to create visual interest without detracting from the foreground subject.

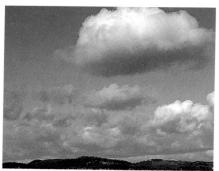

Cumulus clouds are an exciting addition to any landscape. Notice how perspective makes the clouds appear smaller as they recede into the distance. The blue must be used to create a negative shape, forming the clouds.

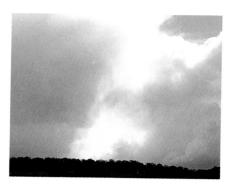

Cumulo-nimbus clouds form a majestic backdrop to a landscape. They create an ominous, dramatic atmosphere.

a sunlit spire against a thundercloud. Remember that variation is essential and never have a row of identical clouds; one of them must always be dominant. A clear sky will need graduation – there is no such thing as a flat blue sky.

TECHNIQUE

The sky is one of the areas of painting in which the hake is invaluable. It can sweep across the paper quickly and its very size prevents 'bittiness' and overworking – the worst enemies of a good sky. To obtain this sweep I push my chair back and stand up, giving myself plenty of room for a unified stroke using my whole arm.

You cannot take a long time over a watercolour sky; if you do you will end up with what I think of as a 'cardboard cut-out' effect. I invariably put a very weak Raw Sienna wash over the whole sky area and try to complete the entire sky while the wash is still damp.

Don't despair if your first efforts are weak and too runny. Ninety per cent of the problem is too high a water content, and once you have learned to control this things will improve dramatically. Remember that a sky will always fade by about 30 per cent when dry, so aim to frighten yourself when putting the colour on. Remember, too, that any strong darks in the foreground painted later will also push the sky back.

Lack of confidence will probably show up more in skies than in any other area of your painting, and the only way to gain confidence is to keep on painting them. After all, the sky will dictate the whole mood of a painting, so it's surely worth a little dedication to produce the best.

In a graduated sky the first step is a weak wash of Raw Sienna. The blue is then put in strongly at the top, with the pressure taken off the brush as it moves back and forth to the horizon. If the paper is at an angle of 45 degrees, gravity will do the rest.

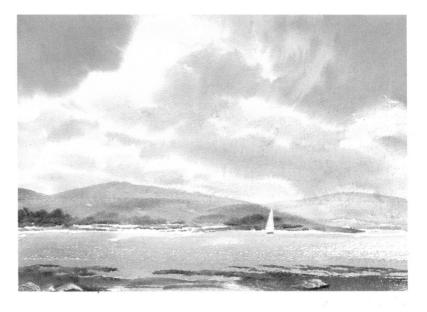

Here is a painted example of a typical cumulus sky similar to the one shown in the centre photograph on the facing page. A sky of this type needs a fairly simple foreground, as one that has plenty of interest in it will compete for the viewer's attention. A point to remember is that one cloud must always be dominant – but make sure you provide weight elsewhere in the painting or the end result will be unbalanced.

Evening Light, Severn Estuary

This demonstration shows how important it is to reflect the colours of the sky in the foreground. In a subject with a rather flat foreground such as this, the colours visible in the photograph may not give sufficient interest and you may need to enhance them.

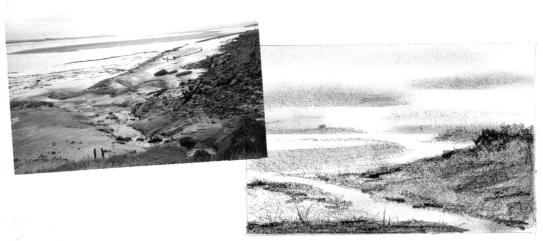

THE PHOTOGRAPH

This was a very exciting photograph to take. I shot it about 1.6 km (1 mile) from my home, with the notorious Severn tide at its lowest. The automatic exposure on the camera was influenced by the light in the sky, so inevitably the foreground is too dark. Nevertheless, this is a good example of the fleeting effects that can only be captured with a camera, as the light would have changed long before I could have completed even the quickest of sketches in watercolour.

THE TONAL SKETCH

When I did the tonal sketch, I made a better lead into the picture by

altering the angle and extent of the foreground stream. The viewer's eye is then taken through to the distant building, following the zigzag design of the sand bar.

THE PAINTING

When painting the scene, it was important to provide unity by reflecting all the existing sky colours in the wet mud and sand; it is easy to make this type of foreground very monotonous by using too few colours. The soft wet-into-wet clouds are a good foil to the crisp directional strokes of the foreground. The distant power station, although tiny, provides a focus for the eye.

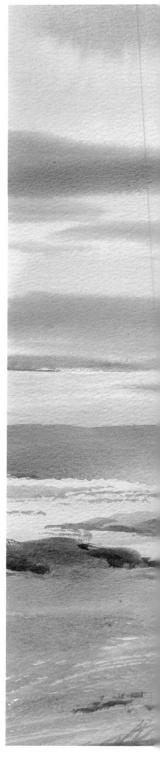

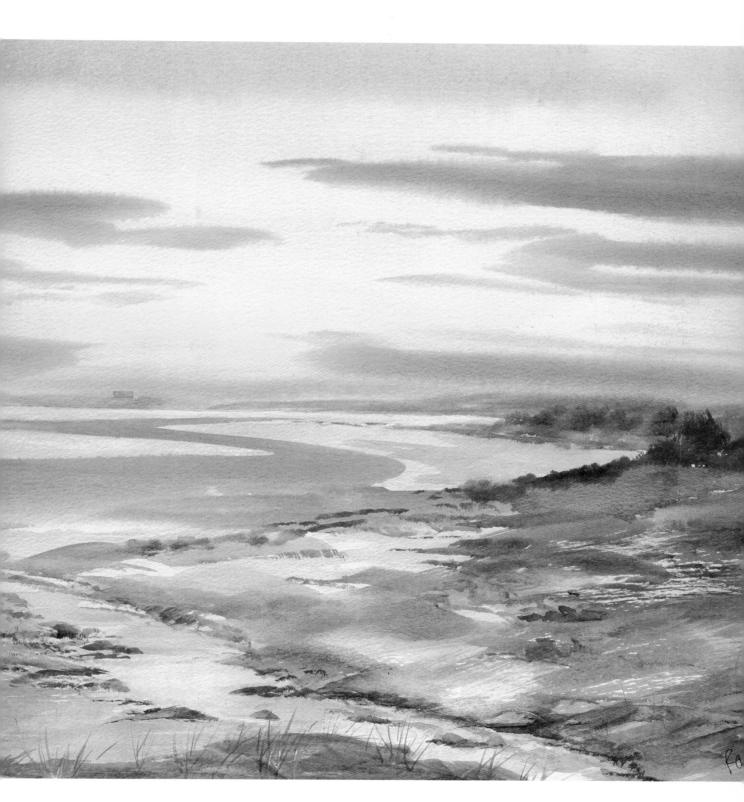

Evening Light, Severn Estuary, 35.5 x 45 cm (14 x 18 in)

Last of the Snow

Here I have borrowed a lowering sky from another photograph to give a suitably wintry effect to a landscape embellished with lingering patches of snow. Using your imagination thus can result in a painting that is radically different from both your starting photographs.

THE PHOTOGRAPHS

These two photographs, loaned to me by students from one of my classes, were combined in one painting. The photograph on the left shows a cumulo-nimbus sky which was reasonably straightforward to paint. The landscape in the photograph below left lacked balance, but masking off the pile of logs improved the scene considerably.

THE PAINTING

Only three colours were needed for this sky: the original Raw Sienna wash followed by a strong mixture of Payne's Grey and Crimson Alizarin. For this type of sky you must steel yourself to put the colour in much stronger than seems necessary. Your board should be on a slope so that the paint can diffuse downwards naturally without help from your brush. Notice how just one cloud dominates the sky, the rest being reduced as they reach the horizon. When I painted the landscape beneath I changed the colours, exaggerated the rise of the land towards the horizon and deliberately left areas of untouched paper to suggest snow. The winter trees are painted mainly with the rigger and finished off with dry brush strokes of the hake.

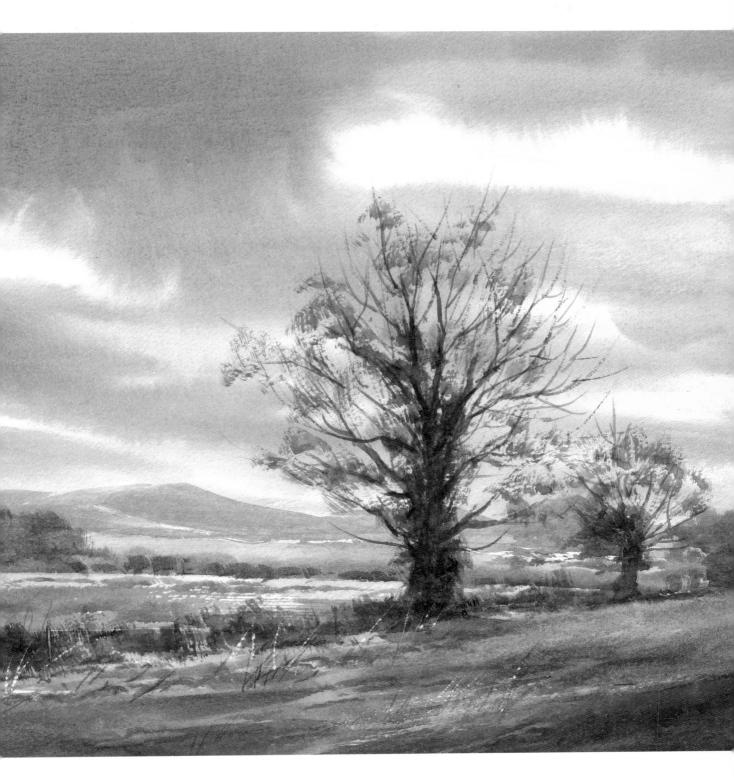

Last of the Snow, 30 x 35.5 cm (12 x 14 in)

Evening on the Loch

Here two very different scenes were combined, with the restless sky in one photograph contrasting dramatically with the still calm of the loch in the other. This demonstration shows how it pays to be adventurous with your stock of sky photographs rather than limiting vourself to obvious matches.

THE PHOTOGRAPHS

The somewhat chaotic evening sky in the top photograph is full of colour and excitement, but as so often happens the landscape that lies beneath it is boring as well as being under-exposed, and certainly not suitable for painting. The photograph below, however, shows a good lead into a pleasing scene, though the foreground needed cropping and the horizon lowering in order to allow more room for the sky in the painting. The photograph also contains some strong texture in the foreground, which I included in the painting to form a good textural contrast with the sky above.

THE PAINTING

When you are painting a sky such as this you use the photograph simply as a reference – not that you would consider executing an exact copy, of course, but in this instance it would in any case be quite impossible. The cloud was done in stages: first the Raw Sienna wash with added yellow was laid, then the main greys made from Crimson Alizarin and Payne's Grey were dropped in while the background was still very damp. I changed the colour of some of the clouds by adding Raw Sienna and a

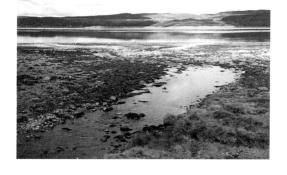

touch of Burnt Umber to warm them up, and made those near the horizon smaller. The landscape was taken from the second photograph, but of course all the colours have been changed so that they match the sky. This repetition of sky colour in the landscape is extremely important: not only is it a good unifying device, but without it the scene would be totally lacking in authenticity.

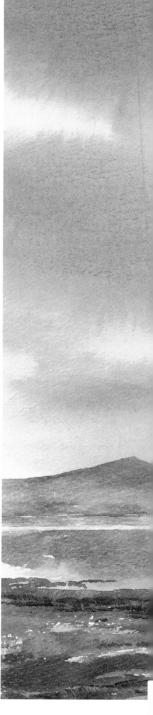

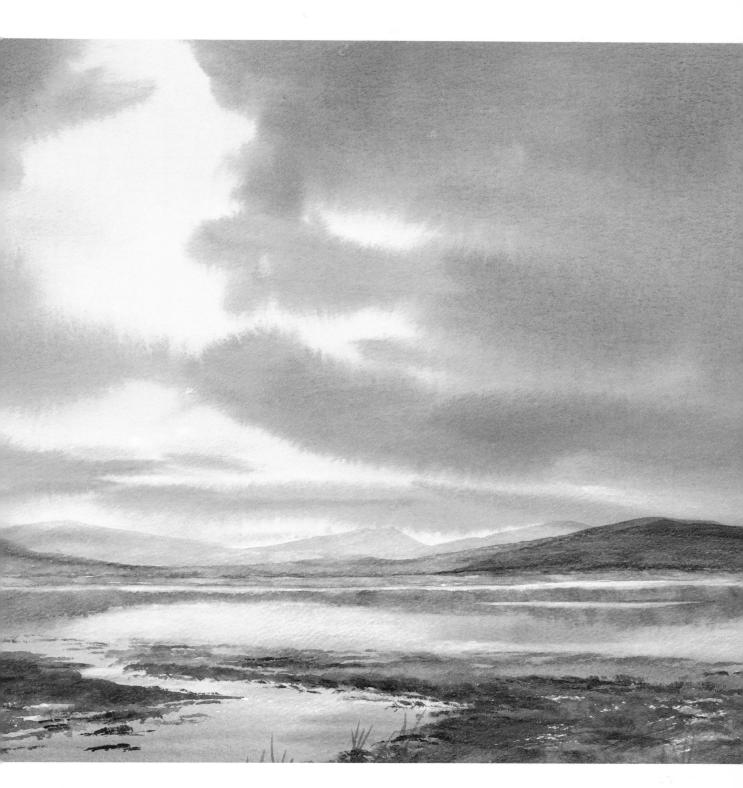

Evening on the Loch, 30 x 35.5 cm (12 x 14 in)

Donegal Lakes

This demonstration shows that it is worth taking a further look for a sky even when the one in the landscape photograph may seem acceptable. Though the photograph below right has an adequate sky, the painting is greatly enhanced by borrowing a more dramatic cloud pattern from the photograph below left.

THE PHOTOGRAPHS

The photograph below left shows masses of cumulus cloud, built up in layers. In order to obtain the right exposure for the sky the landscape beneath has had to be sacrificed. The photograph below right, of a typical scene in Donegal, Ireland, shows good recession, with cool colours for the mountain and warmer browns and ochres in the foreground.

THE PAINTING

I decided on a change of blue for this sky, so I used Prussian Blue. I painted it in patches, leaving the original Raw Sienna wash showing through in places to form the cream clouds. It is sometimes difficult to think of the clouds in this way as negative shapes. I took care to paint the whole sky while the Raw Sienna wash was still damp in order to avoid 'cardboard cut-out' clouds. The grey shadows under the clouds were painted in Payne's Grey and Crimson Alizarin.

When painting the landscape I used the Prussian Blue in the mix to indicate the distance of the mountains then gradually worked forward in stages, warming and strengthening the colours until I reached the foreground.

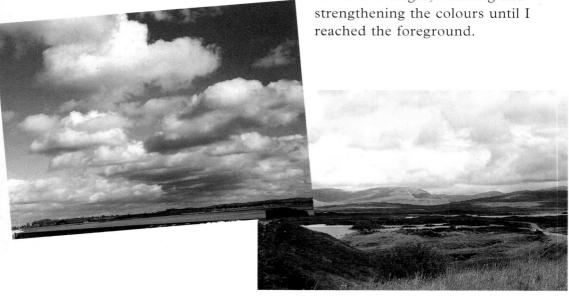

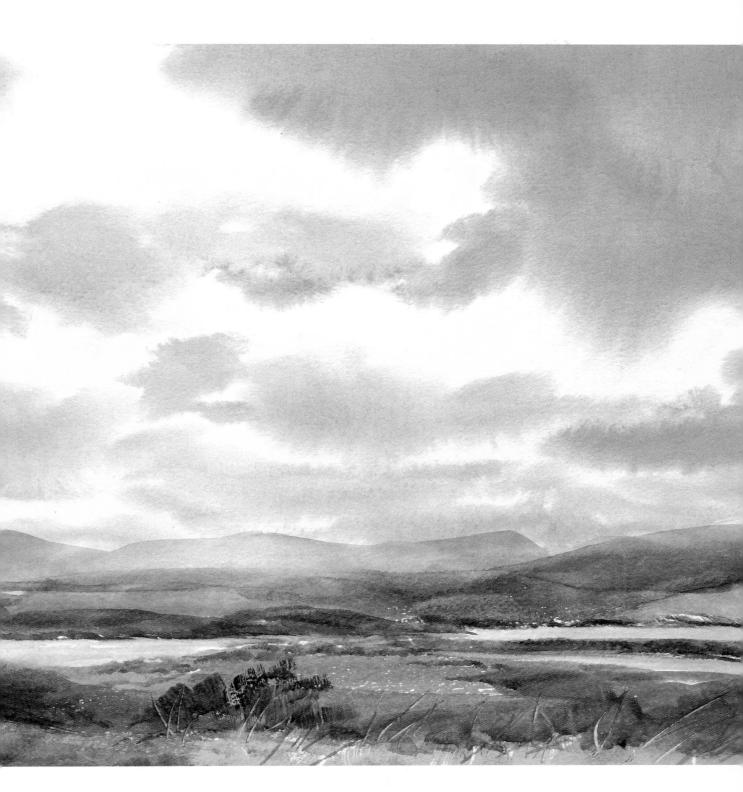

Donegal Lakes, 30 x 35.5 cm (12 x 14 in)

PROJECTS: Skies

Here are several photographs of skies for you to use as the basis for paintings. They are intended merely to act as a guide – it is impossible when painting a free watercolour sky either from a photograph or on location to reproduce it exactly. What you should attempt to do is to convey the essence of the skyscape. Look at the sky, think about how you are going to portray it, then let fly, painting as quickly and boldly as possible – you will find it a really exhilarating experience. Study each of these photographs carefully and decide whether you need to make compositional changes to the landscapes. You will find my interpretations of them on pages 116–117.

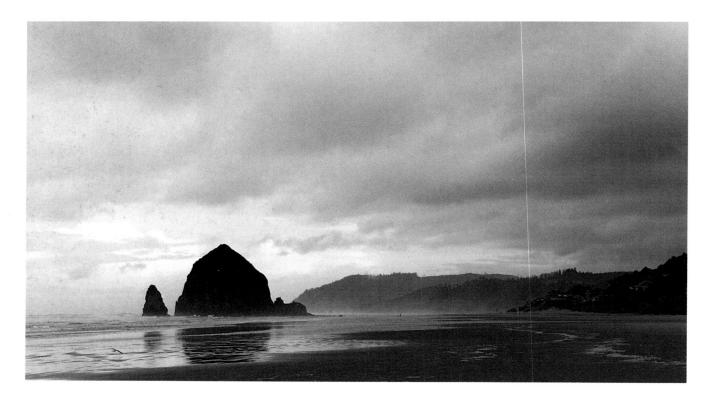

▲ Haystack Rock in Oregon is a famous landmark on America's Pacific Coast and is of course the main object of interest in this photograph. To improve compositional balance, a painting will need the counterweight of a heavy cloud to the right of the scene. The beach in the foreground is a

little featureless, so you should try to introduce some interesting texture and colour here. The sea could be made rougher and the spray used effectively to add movement to the scene; seagulls too are a good source of movement and interest in a sea painting.

■ This photograph, taken from a house in Oregon, is full of dramatic light and colour and you should exploit this as much as possible in your painting. The foreground posts are a distraction and should be removed, but your painting will benefit from the addition of a more pleasing foreground object to add interest. The main focus here, though, is the boiling sky, so make the most of it.

▲ Here low cloud is enveloping the top of the hills, but the impact of the sky is less than it might be because the horizon is high. I feel that the horizon needs to be dropped down the paper in order to allow more space for the sky while still leaving sufficient room to provide texture and colour in the landscape itself. Your object here is to create an

interesting sky, but not one that will dominate the painting. You will also need to create a main object of interest. Any man-made object, even if it is very small, will stand out in a natural environment, so adding a fishing boat would be a solution – but you will need to think carefully about how to position it.

TREES AND WOODLAND

It is with this subject that the greatest difference between the photographic image and the final painting occurs. If you photograph a woodland scene, or even a single tree, the resultant image will show thousands

of individual leaves, twigs and branches. It would be impossible to paint each one, and in any case you should not aspire to. Your aim is to produce a fresh impression with all the atmosphere and depth of the scene without the detail.

SEEING THE STRUCTURE

Trees are beautiful in their own right and are an asset to any landscape, so they deserve careful study. As with any other subject, you will not achieve good results by relying on a photograph; you must have knowledge of your subject, so take every chance you can to look carefully at trees in all seasons. For example, in winter a deciduous tree will show you its skeleton, giving you the chance to learn the basic shape beneath the summer leaf canopy. Notice how distant trees lose their individuality and become a single overall mass.

Whether or not they appear in your photograph, it is important to leave sky holes in your painting in which to indicate branches and twigs – never paint branches on top of foliage masses. Gradually thin the branches as they reach the outside edges of the tree, combining them with the holes to form an interesting silhouette.

Just as important as the trees themselves is what grows beneath them. Foreground undergrowth should be contrasting and full of variation, but avoid the temptation to overwork by painting quickly and lightly. Many a painting is spoiled by an overworked, muddy foreground.

CHOOSING THE COLOURS

At every time of year you will have to use a far greater range of tree colours than those shown in your photograph in order to avoid a flat, monotonous effect. In an autumn woodland scene, for example, I start painting with a variety of mauves in the background, giving an impression of distant autumn foliage. This gradually changes to rich reds and browns in the foreground. In winter, a variety of blues and browns dominate; Burnt Umber and Ultramarine used in varying proportions are what is needed here - a higher proportion of blue in the back, and more Burnt Umber at the front. Even a single tree should have a variety of colours in it.

Foreground trunks must never be a plain untextured brown; if you observe tree trunks carefully you will discover a variety of greys, pinks, even blues. Side lighting in your

painting will help to emphasize the roundness of the trunk as well as anchoring the tree to the ground and offering the opportunity to

Morning Sunshine 40.5 x 30 cm (16 x 12 in)

Here I painted the sky first and then dropped in the distant woodland wet-into-wet. keeping the colours very cool. Working forward, I added progressively more warmth and also strengthened the bare trees. The branches were put in with the rigger. The water went in as a very pale Raw Sienna wash, and I immediately dropped in the reflections wetinto-wet. Those of the main trunks were put in with rich paint so they would register strongly. Finally, I used white gouache to paint the strong light edging the tree trunks.

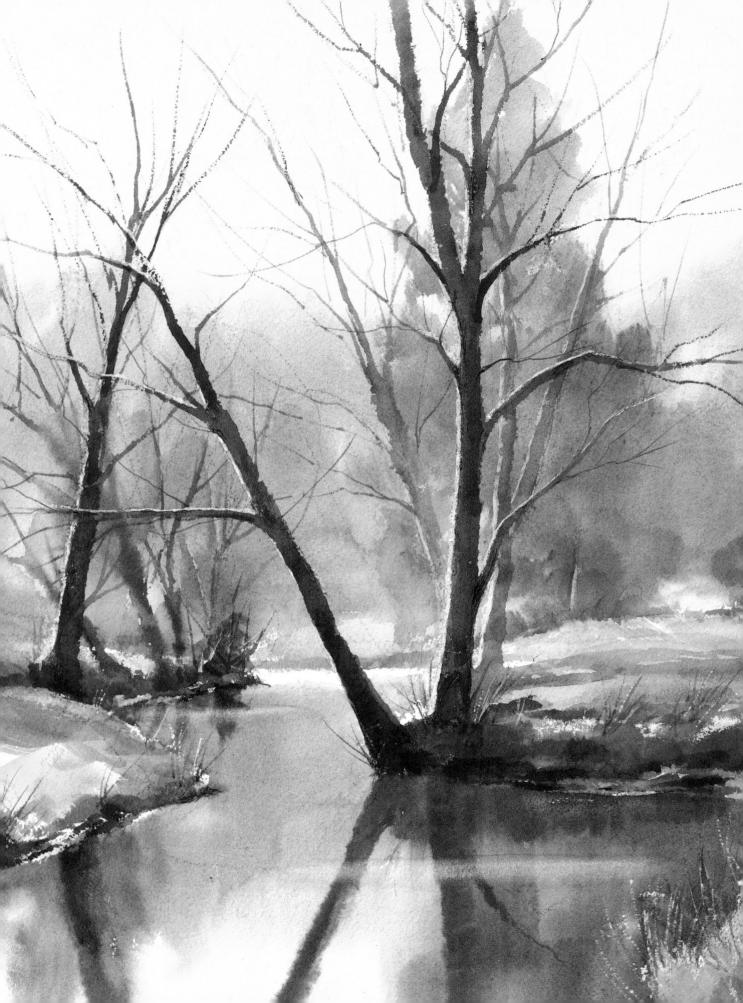

create contrast and excitement with interesting shadows, regardless of whether they are present in the photograph or not. If you want to portray a really large tree, show only a small part of it in order to suggest its massive bulk.

USING THE RIGHT BRUSHES

The only two brushes I use for trees are the hake and the rigger. For distant trees, I employ the corner of the hake to produce the ragged profile of trees against the horizon, then a gentle touch with the edge to create the base of the wood.

I use a sideways motion with the edge of the hake to represent the trunks more to the fore. I then switch to the rigger to delineate branches and twigs, using varying pressure – heavy for the thicker branches where they come off the trunk, and reducing to a feather-light touch for the finest twigs. It takes practice with the rigger to produce authentic tapering branches, but it is time well spent, especially when you are

painting winter trees. Tapping the paper with the back of the hake produces very realistic foreground foliage that does not look overworked. The rigger is the brush to use for grasses and undergrowth beneath the trees, but do be economical with it, just suggesting grasses rather than overworking them.

DEPTH OF FIELD

In a photograph a foreground tree has virtually the same value as a distant one, whereas in a painting you will need to create depth of field by deliberately cooling the colour in the distance and massing the trees together as one single unit. As you move forward in the painting, warm the colour, reserving the richest tones and detail for the foreground - in other words, exaggerate the aerial perspective. You need to bear in mind that you are trying to portray on a flat piece of paper a scene which may stretch back miles from the viewer. A distant hillside, while it may consist of thousands of trees,

■ This shows how the rigger is used for the fine branches on winter trees. The width of the branch is dictated by the amount of pressure on the brush, which is held at the top end to allow freedom. You may need a fair amount of practice before you can produce these winter trees with confidence and conviction, but it will be time well spent.

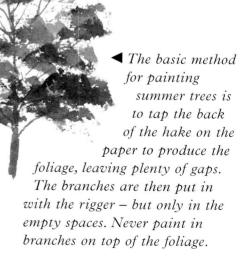

can be convincingly expressed by just a swift stroke of the hake.

I very much enjoy painting misty woodland as I love the wet-into-wet effects I can achieve at the back of the scene. The whole of the background is painted wet-into-wet, even the rigger work, which of course diffuses. As the

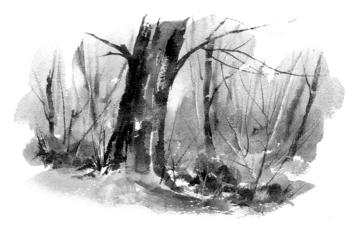

▲ This illustration shows a woodland scene and demonstrates the texture of a foreground trunk. The background has been kept deliberately wet-into-wet in order to avoid a conflict of interest. The foreground undergrowth is painted in much richer, stronger paint. The main trunk has been painted with the hake; everything else has been put in using the rigger and a fingernail.

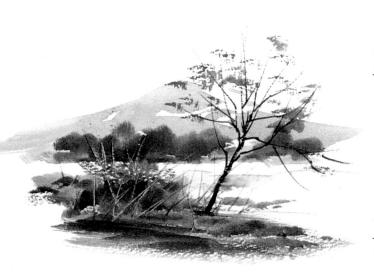

paper dries, I move forward so that the trees become sharper and warmer as they reach the foreground.

When you are painting woodland your aim should be to give the viewer the feeling of being able to walk into the wood. Woodland scenes often incorporate pathways, and these should wander rather than being straight, with an exaggerated perspective so that they take the eye right into the scene. This is one of the many changes you may have to make to your original photograph. One of the most frequent faults in photographs of woodland is that they do not have enough depth of field, and you will need to rectify this in your painting.

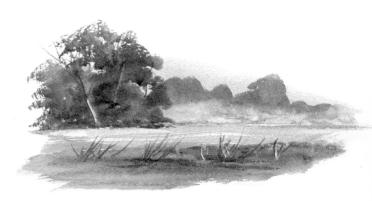

▲ Using cool and warm colours as shown here creates depth in a landscape. I have added more water to the paint at the base of the distant trees to give an impression of mist. Don't overdo foreground texture - often just a hint is sufficient.

◄ This is a good example of foreground grasses and texture. Again, the background trees have been put in wet-into-wet to push them back, while the foreground is put in with richer paint. I've used the corner of a credit card to create the light grasses, scratching them out while the paint is still damp.

Misty Creek

The comparison between the photograph and the finished painting here is an excellent demonstration of what this whole book is about. The painting is a distillation of the photograph rather than a reproduction of it, improving upon the composition and enhancing the mysterious atmosphere of the location.

THE PHOTOGRAPH

This photograph of an American creek, lent to me by my friend Dr Don Fisher, is highly evocative of the raw feel of a damp and misty day in winter. However, it was taken in the poor light conditions that inevitably prevail at such times and is therefore lacking in definition and contrast. Because of this it appears dull and rather

flat. However, it offered me the opportunity to use my imagination to produce a moody and exciting watercolour by adding more contrast in colour and tone. I also needed to simplify the whole scene by clearing away all unnecessary clutter, starting with the tufts of vegetation that are just visible at the very bottom of the photograph.

THE PAINTING

This is essentially a wet-into-wet painting. First I covered the whole paper with a Raw Sienna wash and then I dropped in the trees and foliage with various strengths of paint, sometimes using it almost neat. I had to work very quickly and freely, using my fingernail to delineate the light branches and a piece of credit card to scrape off the tops of the rocks. The sparkle on the water was obtained by using a very fast and light stroke of the hake.

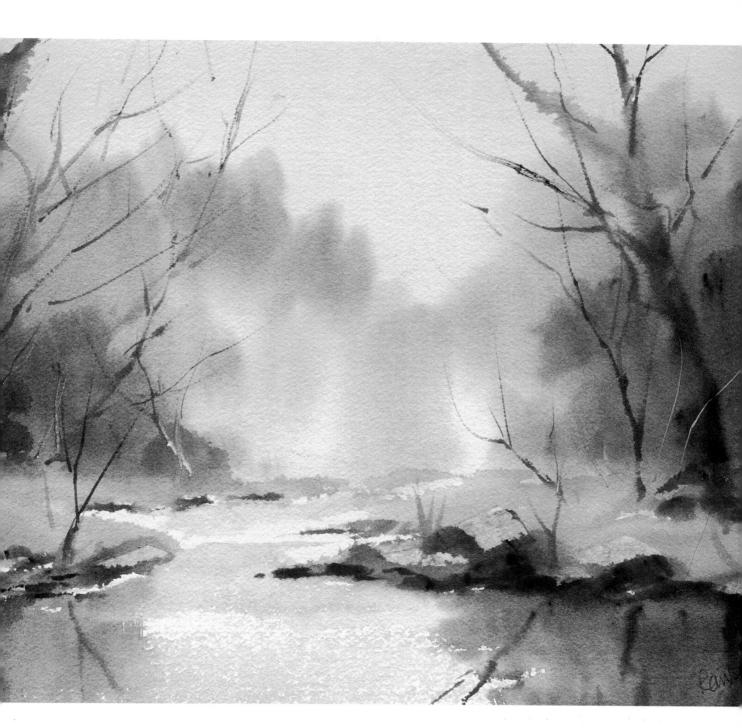

Misty Creek, 30 x 40.5 cm (12 x 16 in)

Winter Shadows

The photograph and painting here demonstrate how even a small alteration of colour or shape can have a major impact on the design of a picture, turning a rather unbalanced photograph into a painting that is compositionally satisfying.

THE PHOTOGRAPH

I got much enjoyment both out of taking the photograph of this wintry field and converting it into a watercolour. However, the photograph lacks balance, with nothing to counterweight the strong shape of the trees to the left. The right side has no point of interest to contain the viewer's eye within the scene.

THE PAINTING

When I painted the scene I corrected the composition simply by lengthening the shadows

so that they stretched all the way across the field to the right-hand side of the picture. I also made a little more of the far trees on the right of the picture. The tree skeletons cried out for plenty of calligraphy with the rigger, which contrasted well with the indistinct mass of the distant trees. When I was painting in the shadows I had to work with speed and decisiveness as there was no second chance here - shadows must be kept transparent. The untouched snow was left as completely white paper.

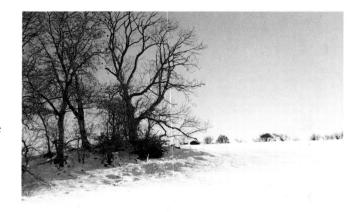

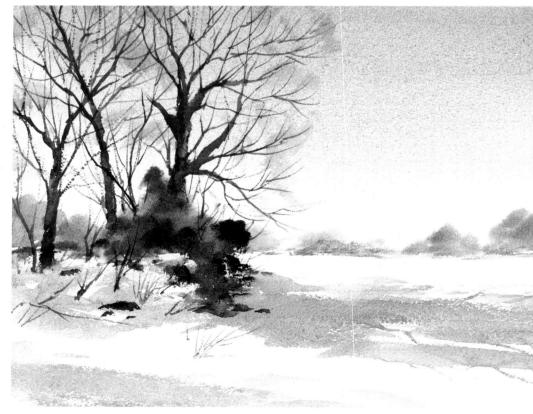

River Bend

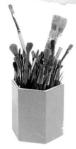

Trees usually cast strong reflections in water and these can provide plenty of interest in a painting. Here the light on the water has been exaggerated somewhat to take full advantage of this.

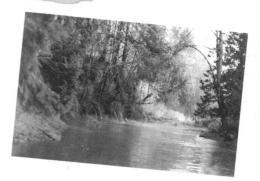

THE PHOTOGRAPH

What drew me to this scene was the contrasting pinks and greens of the vegetation complemented by the mauve reflections cast by the trees.

THE PAINTING

After putting in the sky I dropped in all the background woodland wet-into-wet, using Crimson Alizarin and Ultramarine. Once this was dry I painted in the foreground woods with rich green, dropping in plenty of reds at the base to avoid monotony. The pinks and mauves of the distant trees were repeated in the shadows on the river banks in order to provide unity. The trunks of the trees were put in using sideways strokes of the hake. Finally, I painted the river itself, with the reflections of the trees going in with vertical strokes, wet-into-wet. The sunlit patch of water provides the painting with a good centre of interest.

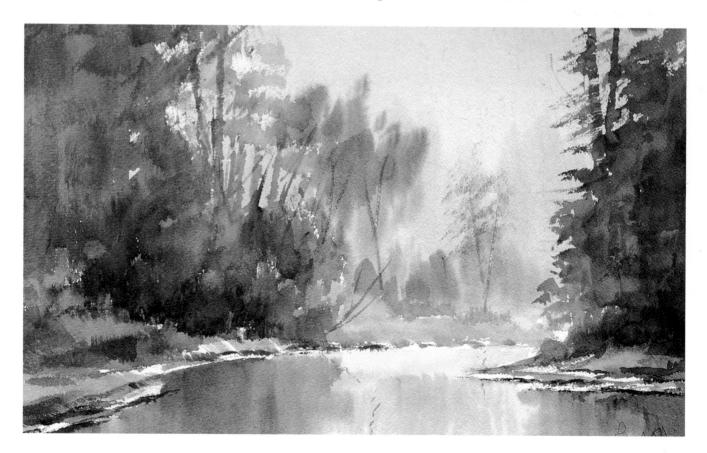

River Bend, 30 x 40.5 cm (12 x 16 in)

The White Barn

Some photographs are suitable only to be used as a reference point for certain aspects of a painting; others stand quite well as pictures in their own right, needing just minimal alteration to make a satisfying painting.

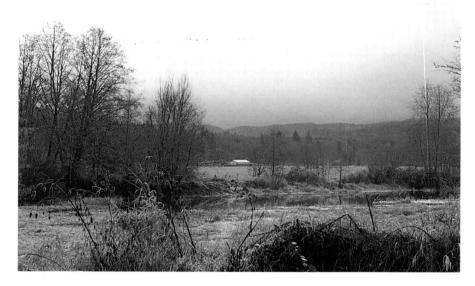

THE PHOTOGRAPH

This photograph is pleasing in both composition and colour and very little design change was needed to transform it into watercolour. However, as the white barn is the main object of interest, I decided to make minor alterations to focus the viewer's attention firmly upon it.

THE PAINTING

I felt that some of the minor trees in the middle distance would be best eliminated so that they did not distract the eye from the barn. I also left out the tree branches just in shot on the right to give a less cluttered

feel and cleared away some of the foreground brush to allow easier access into the picture. The main difference between the photograph and painting, though, is that to provide more warmth and contrast I made the distant colours richer, introducing purples mixed from Crimson Alizarin and Ultramarine. These contrasted well with the warm colours of the field and riverbank. I used purple again in the foreground, creating a feeling of unity in the painting. I also moved the area of heaviest cloud, lifting it from the horizon to allow greater contrast between the hills and sky.

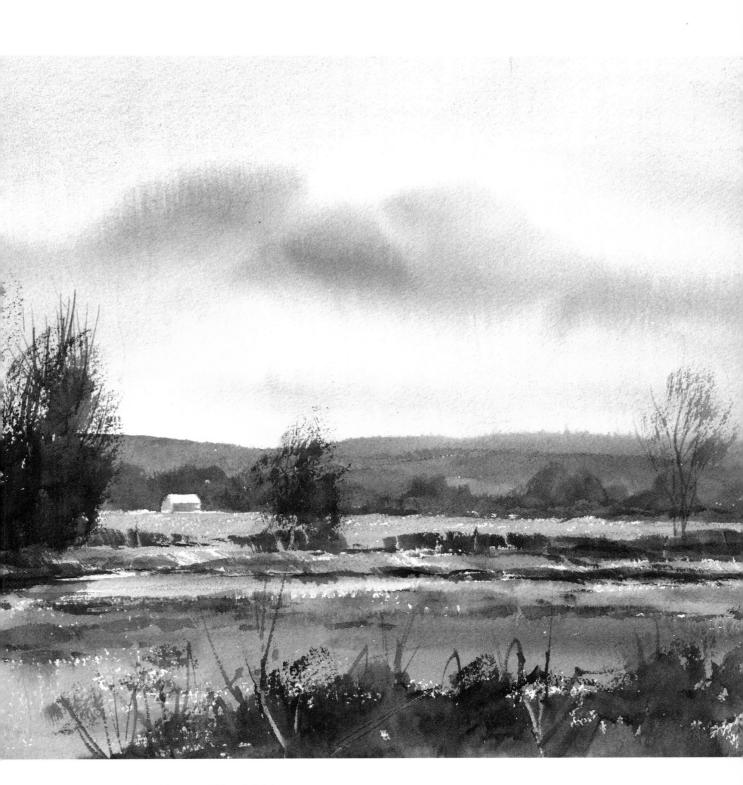

The White Barn, 30 x 40.5 cm (12 x 16 in)

Winter Reflections

This painting of the reflections of skeletal winter trees in water shows that it is sometimes possible to have the luxury of using a photograph almost as it is without having to deliberate about how you can improve the composition or colours.

THE PHOTOGRAPH

Sometimes you may be fortunate enough to find a photograph which is full of potential and cries out to be painted as soon as possible. This is one such – an absolute natural. It needed virtually no alteration.

THE PAINTING

Painting the graduated sky was a straightforward task; I laid a thin Raw Sienna wash and immediately afterwards applied a mixture of Prussian Blue and Ultramarine. Next I put in the background scrub, which was a mix of Raw Sienna and Light Red, with the darker patches in Ultramarine and Light Red. The group of trees was a delight to paint, with the rigger and dry brush hake. The snow was mainly left as untouched paper. Now came the river, which had to be done quickly and decisively. A first wet wash of varied blue and Raw Sienna was followed immediately, wet-into-wet, with rich browns and blues for the reflections. Finally, a few squiggles with neat paint indicated the trunks of the trees.

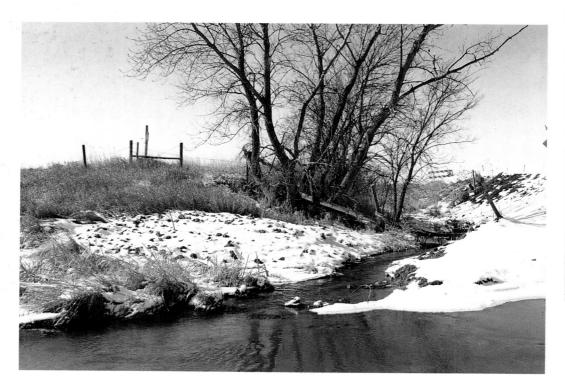

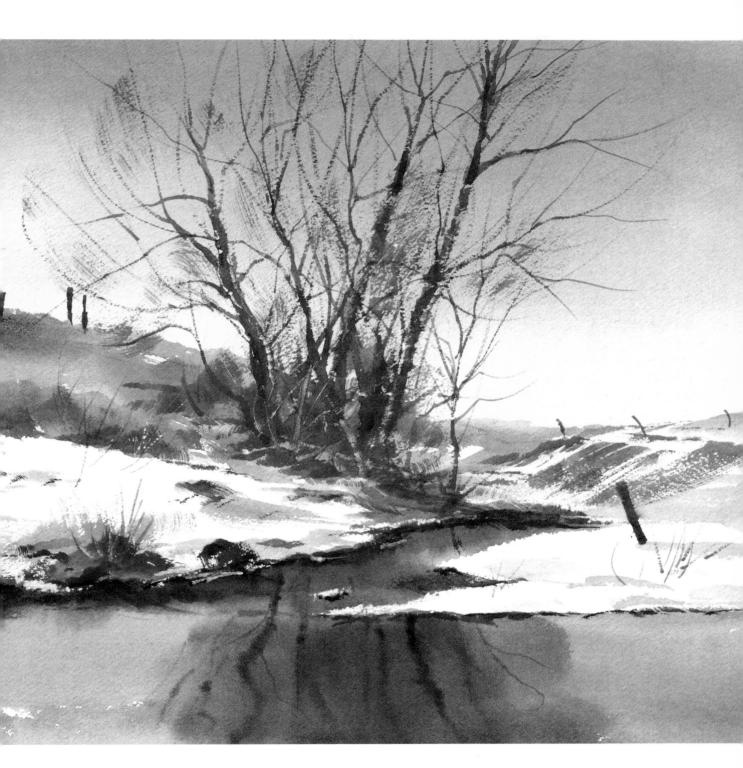

Winter Reflections, 30 x 40.5 cm (12 x 16 in)

PROJECTS: Trees and Woodland

When you are tackling these subjects remember that although the photographs may show every twig and leaf, your job is to produce only the general effect of trees and foliage. In other words, make great efforts to restrain yourself from copying and symbolize the scenes instead. Study each photograph carefully and decide what changes you want to make. For example, you may wish to improve the composition or to eliminate certain aspects altogether. My interpretations of these photographs are on pages 118–19.

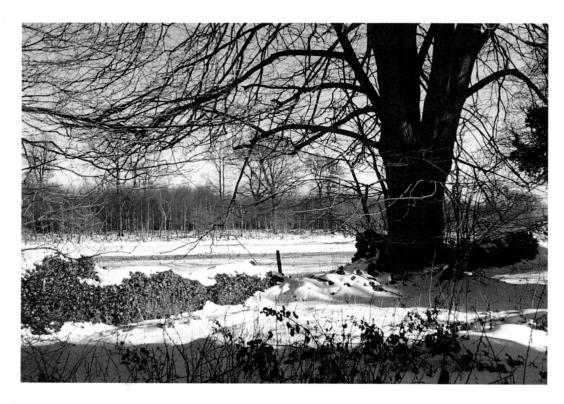

▲ The main object of interest here is the tree, of course, plus the wonderful shadow patterns created by sun on snow. However, the strong shadow running across the bottom of the photograph seems to create a barrier, keeping the viewer out of the scene, so you may want to consider removing some or all of this in your painting. Think how you might draw the viewer's eye into the painting instead. The branches of the main tree will need to be simplified and the distant woodland might also need some attention to make it more interesting.

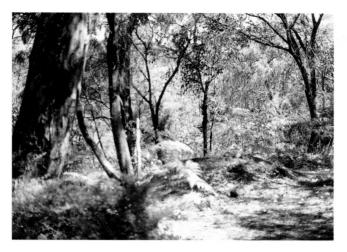

■ This photograph was taken on a very hot summer's day in the woods. Your main problem will be to create depth in your picture. You might decide to do this by keeping the greens in the distance fairly cool and painting them wet-into-wet, and then using warmer and stronger greens in the foreground. You will also need to simplify the picture considerably. Don't attempt to indicate every branch and leaf, even in the foreground - the temptation with this type of picture is to overwork, but you have to learn to stop as soon as you have captured the atmosphere. Try to retain the strong contrasts of light and shade in your painting.

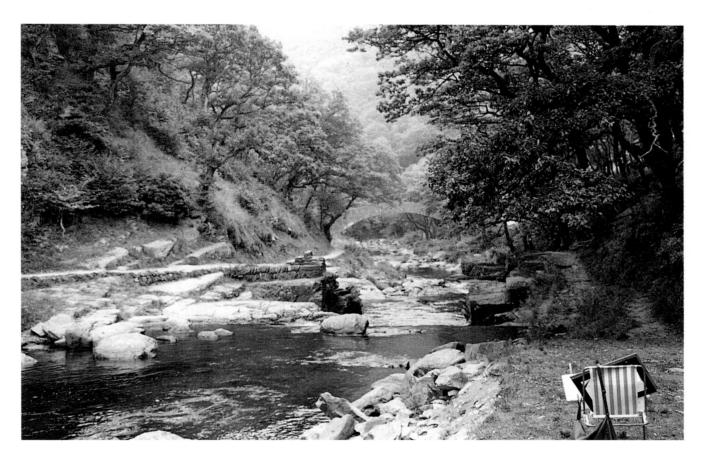

▲ This type of scene lends itself ideally to watercolour. The composition of this photograph is fairly good as it stands apart from the striped deckchair, which you will probably decide to remove. Again you will need to think about

creating depth, and how you will set about portraying the distant tree-covered hillside. You might consider moving some of the trees in order to allow a better view of the bridge and the hill in the background.

WATER

While skies are my favourite subject, water comes a close second; looking round 85 of my paintings in a recent exhibition, I realized a very high percentage of them depicted water in one form or another. Of course, water

appears in a very wide range of subjects: boats, harbours, sea shores, rivers, lakes, estuaries, waterfalls, even the humble puddle in the road. The mood can range from raging torrents to tranquil lakes.

TECHNIQUES FOR PAINTING WATER

When working from photographs, you will often have to make changes to the water in some way to make it look authentic in a painting. This can be done by using various techniques. For example, the tumbling white water of a fast-flowing river can be made to look really exciting by using fast strokes which follow the direction of the water, leaving plenty of white paper showing. In still water you may have to put in reflections which aren't in the photograph, perhaps because the surface was ruffled at the time. Reflections are an excellent way of unifying a painting. Conversely, I often wipe out a streak to indicate a patch of disturbed water, which adds interest. This is particularly effective where the water is darkest.

In the painting of water, the watchword is economy – many water scenes are ruined by overworking. Hundreds of ripples carefully painted in can kill a painting stone dead. Aim

to put in the minimum of strokes, leaving some work for the viewer to do. The reflection of a post or tree in the water can be portrayed by just a slight wriggle of your brush, while untouched paper for white water can be just as descriptive as paint – but don't leave too many conflicting whites in other parts of the painting as they will dilute the effect.

When I am painting a large stretch of open water I often make it dark at the front and graduate towards the back to give the impression of depth, whether or not this appears in the photograph. The best way to do this is to paint the rest of the picture first then turn it upside down, put it on a sloping board and wet the whole surface of the water lightly. Put in a strong wash at the front, lessening the pressure on the brush as it moves towards the horizon, then allow gravity to do the rest. This means that the line of the horizon will not be encroached upon.

PAINTING ROCKS

Another aspect of painting water scenes is the portrayal of rocks. Don't feel you must reproduce those in the photograph; you are quite free to take them out, reduce some and enlarge

others. They can supply contrast with the water – another feature of good design. Increase the contrast between the top and sides of the rocks to add drama to your composition.

Welsh River in Flood (detail)

This painting, based on a black and white photograph in a guide book, shows how leaving plain white paper conveys the feeling of rushing water. I have given depth to the scene by using restrained colour in the background and strong, contrasting colours for the foreground rocks.

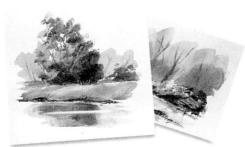

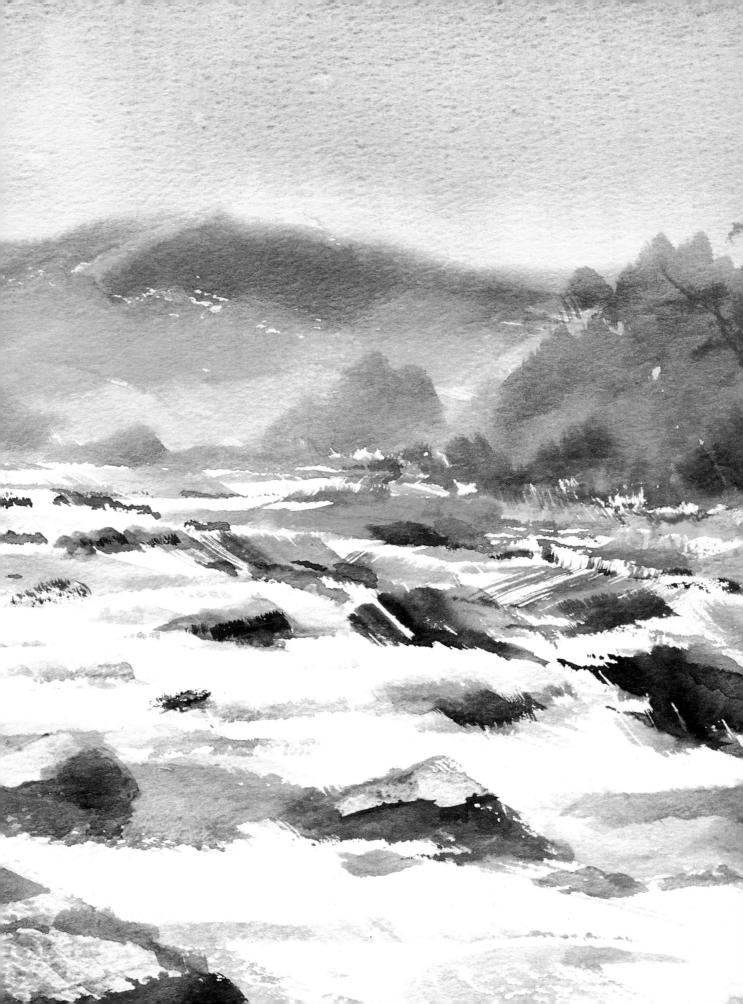

BRUSHSTROKES

Generally, I use the hake for my water scenes, employing it in many different ways. I love the sparkle it gives when it is used to make one sweep lightly and quickly across the sea or a lake. It just touches the surface of the paper, taking only seconds to do but giving an effect you could not obtain with hours of work. I particularly enjoy painting estuaries at low tide, where there are dry sandbanks which again have to be put in with one quick flourish of the brush to give them spontaneity, the wet sand and mud reflecting the colours of the sky.

When painting seascapes I like to stand up and use my whole arm to produce spontaneous curves to depict the waves, leaving white paper for their crests. The shoreline too must be put in with simple sweeps and then left alone – fiddling about

with it afterwards is always disastrous. Again the hake is ideal for this type of work.

Water scenes very often include boats, and your main aim here should be to simplify them. You may be tempted to copy every detail you can see in the photograph, but as long as the overall proportions are right it is surprising how little detail you actually need. The 25 mm (1 in) flat, used judiciously and delicately, will do the job and prevent you from the over-elaboration that might result from using a smaller brush. It is obviously important that the style of boats should match the context of the waterscape.

COLOUR IN WATER PAINTINGS

Don't make the mistake of mixing up a wash of blue and painting the whole water surface, no matter how large, with that one colour. The

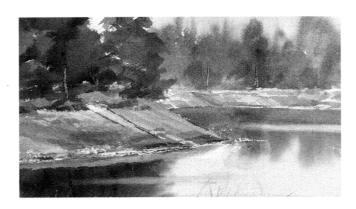

To paint these reflections in calm water I first put on a thin wash of sky colour and then brushed in the vague tree shapes vertically while the wash was still damp. I then used stronger, richer paint for the foreground reflections. The soft streaks were taken out with a dry hake while the paper was still damp.

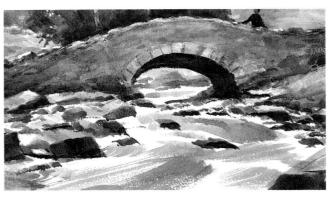

This fast-flowing river is portrayed by making full use of the white paper. The colour has been put on with a hake, using fast, light strokes in the direction of the flow. Remember that the more economical the strokes are the better the result will be.

surface of the sea or a lake changes colour constantly, especially in the shallows where the sand or pebbles show through. This graduation of colour, one of the fundamental principles of design, is particularly important here in order to avoid monotony.

Water itself is colourless but it reflects every colour around it, be it from the sky, from trees or from buildings. However, the sky colour must always influence the water as this plays a large part in the unification of the picture. It is important to remember this if you are using two separate photographs, one for sky and one for water.

Be careful not to be too influenced by the colour of the water in a photograph. Many rivers will appear brown and muddy after rain, and this will not make for an attractive painting. The colour of the river should rely more on the sky above and trees around it rather than the mud particles within it, which also cut down reflections.

When painting ponds or lakes I paint in the general sky colour first, then drop in the

reflections of whatever lies behind them in rich paint to compensate for the dampness of the surface. This will soften to produce the right effect, but will still appear in virtually the same tones as the original object.

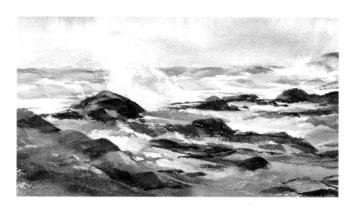

When depicting foreground waves and rocks the challenge is to convey the idea of liquid, moving water against the hard, rigid rocks. To do this you need to use every opportunity for counterchange to create visual excitement. You should also put in plenty of varied colour.

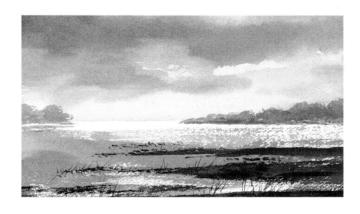

In this tranquil scene the water is sparkling with reflected light. To achieve this, first put in the sky, then take a hake brush full of the same colour and sweep it very lightly and quickly across the water area so that it just catches the surface of the paper. When this is dry, you can put in the foreground shoreline.

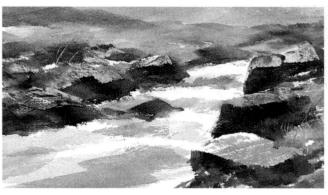

The main things to remember when painting rocks is that the tops must be light and the sides dark, and that the colour must be varied. In some of the rocks here I used a piece of credit card while the paint was still wet to scrape off the top surfaces. In others I painted the top surface light and used stronger, darker paint for the sides.

Oregon Lake

This demonstration shows how useful a tonal sketch can be when working from a photograph, particularly one with a variety of different forms within it. It reduces the scene to a simple pattern of lights and darks and suggests how the tones of the photograph may be modified to increase depth and contrast.

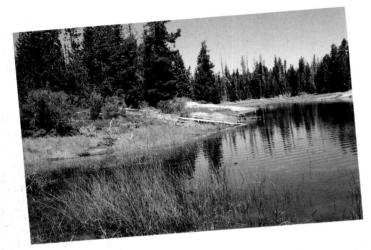

decided to add the family canoe drawn up on the bank to provide the scene with the necessary focus of interest. I altered the curve of the shoreline so that it would draw the viewer's eye into the picture and reduced the amount of rushes.

THE PAINTING

In my painting I cooled the colours of the

distant trees to create a feeling of recession and strengthened the colours of the nearer trees on the left. Notice that the reflections in the water also follow these changes. They were put in wet-into-wet on top of the sky-coloured water of the lake.

THE PHOTOGRAPH

I took this photograph while I was on family camp in the wilds of Oregon in the USA. There was plenty of interest here for a painting of water, with reflections of the sky and the pine trees, rushes growing in the foreground and a riffling of the water surface caused by a light breeze.

THE TONAL SKETCH

I wanted to add more depth and contrast in my painting of this lovely place so I included some distant snow-covered mountains in my tonal sketch to help achieve this. I also

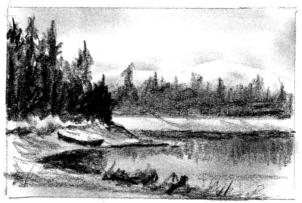

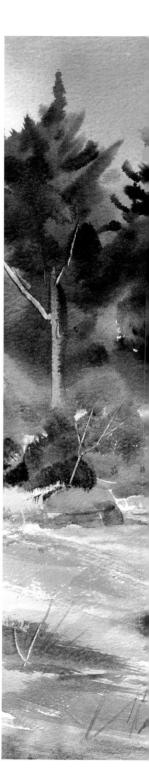

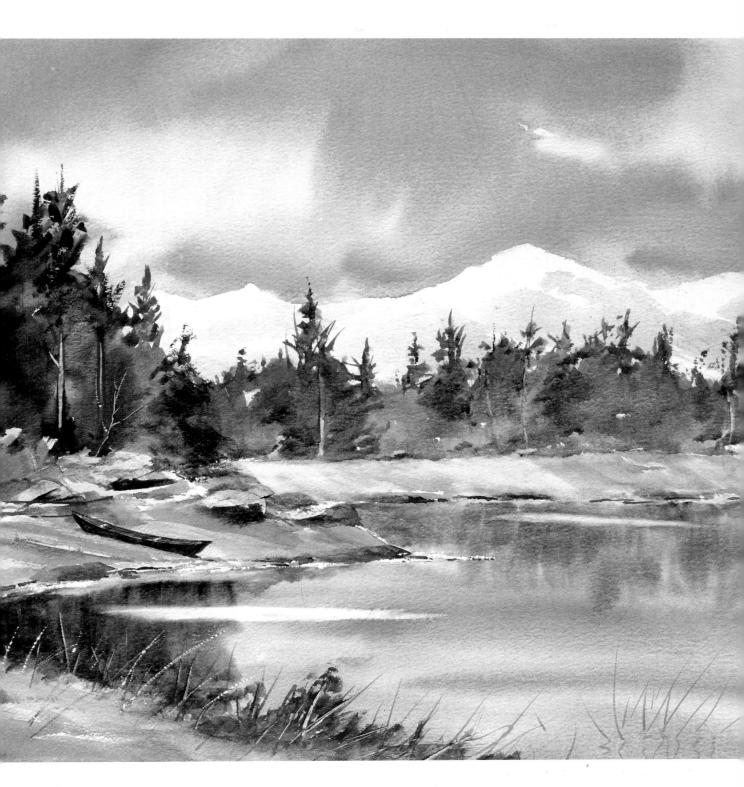

Oregon Lake, 33 x 43 cm (13 x 17 in)

Australian Peninsula

Often you may have to emphasize the lights and darks in a tonal sketch to obtain sufficient contrast in your finished painting. In a subject such as this, however, which contains dark landscape features and foaming white waves, you need do little to improve upon the scene.

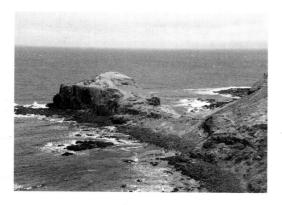

THE PHOTOGRAPH

I was attracted by this curiously shaped peninsula in Australia, with its starkly different planes and variety of textures ranging from the rocky beach to the smooth, well-worn path. With no distracting objects to mar the view, it was obvious that it would translate well into a painting.

THE TONAL SKETCH

The photograph contains plenty of contrasting light and dark in the white waves and dark rocks and I did not have to search for more. The only significant change I made was to put in a line of distant hills on the horizon, which existed in reality but did not show up in the photograph.

THE PAINTING

In the finished picture I have simplified the sea, as attempting to reproduce the waves too closely would only have resulted in a static effect. I have also introduced more colour in the cliffs and beach by adding complementary mauves. Notice how the brush strokes follow the general profile of the land mass to emphasize its form.

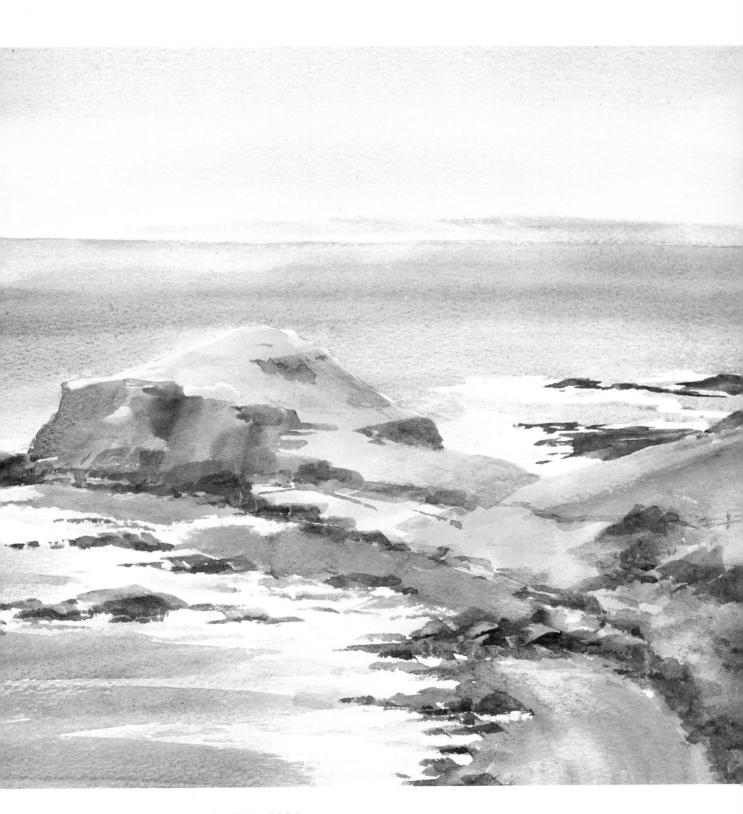

Australian Peninsula, 28 x 35.5 cm (11 x 14 in)

River Gorge

This is an example of how the dimensions of a landscape-shaped photograph can be completely changed to make a portrait-shaped painting. Altering the proportions of a scene in this way not only affects its composition but can also shift its emphasis considerably.

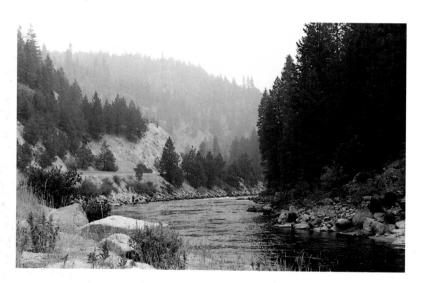

THE PHOTOGRAPH

It is always a help in this exercise to use two or three pieces of white paper to crop the photograph in various ways, moving them around until you frame the most interesting section of the scene. In this photograph the steep wooded banks of the river largely dominate the scene, and I wanted to focus the viewer's attention on the river.

THE TONAL SKETCH

By cropping the banks I have thrust the river into prominence so that it is now unmistakably the main focus of attention. The sky also appears a more major part of the composition, though in fact the proportion of it in relation to the trees has not changed.

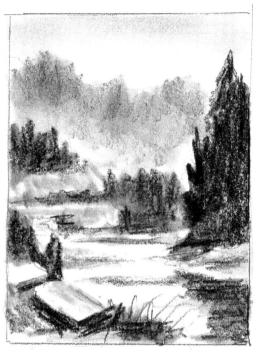

THE PAINTING

You will see that I have made the water faster-flowing by leaving white paper to create the impression of foam and have intensified much of the colour in order to provide contrast and depth. The pinks have been repeated throughout the painting, giving a feeling of unity between the foreground, middle distance and far distance.

River Gorge, 40.5 x 30 cm (16 x 12 in)

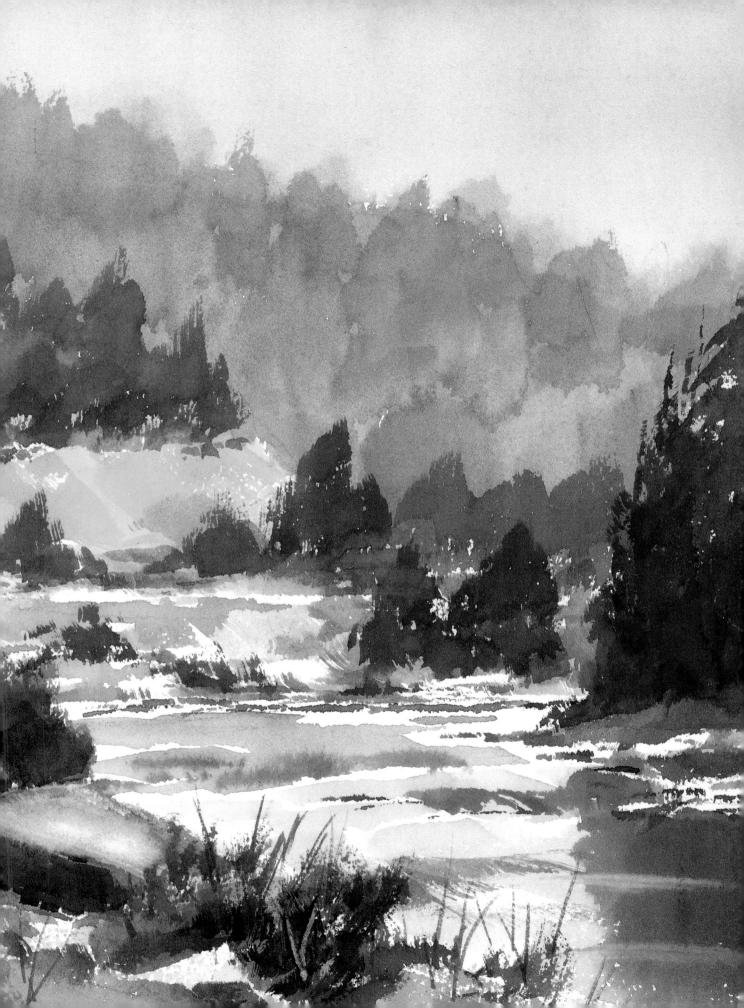

Misty Hills

Sometimes a photograph dictates exactly how you should translate it into paint. Here the treatment to use is unmistakably large areas of wet-intowet to suggest the watery and misty effects, with dry brush to point up the foreground details.

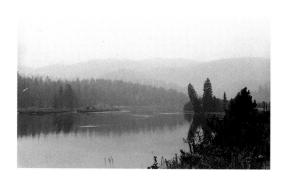

THE PHOTOGRAPH

The striking shape of this pair of trees caught my attention and I liked the way they were both reflected in the water and silhouetted against the misty hills behind them. All in all, it seemed an ideal photograph for an atmospheric painting in which the wet-into-wet technique would predominate.

Misty Hills, 30 x 40.5 cm (12 x 16 in)

THE PAINTING

It wasn't necessary to make many changes to this photograph other than straightening the leaning tree and leaving an area of mist behind both trees to produce a stronger focal point. The river was put in very much wet-into-wet, and shows how little needs to be done to give an authentic impression. I used dry brush technique on the foreground bank to provide contrast with the treatment of the river.

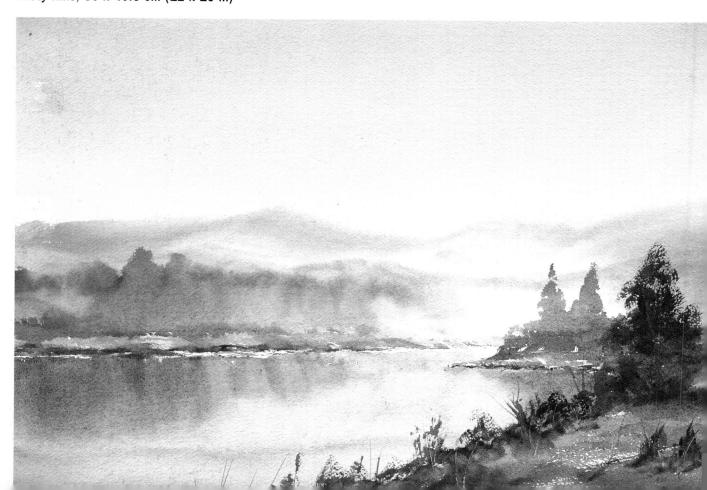

The River in Winter

The combination of snow and water often makes for a dramatic painting, with the dark reflections of trees echoed by the shadows thrown on the whiteness of the snow. This demonstration shows how much colour you can find in what might first seem a monochrome subject.

THE PHOTOGRAPH

There is plenty in this photograph to attract a watercolour artist, with the linearity of the stark tree trunks counterpoised against the horizontal planes of the water and snow. The swirling water here also offers plenty of interest, with some of the reflections broken and others more clearly defined.

The River in Winter, 30 x 40.5 cm (12 x 16 in)

THE PAINTING

The composition of the photograph was good, so my main task was to add variation in colour to the background trees to avoid the monotony of too many greys and browns. To paint the water, I first put on an overall wash and while this was still wet dropped in the reflected colours with rich paint and enjoyed watching them diffuse. The reflected trunks were put in just before the surface dried completely.

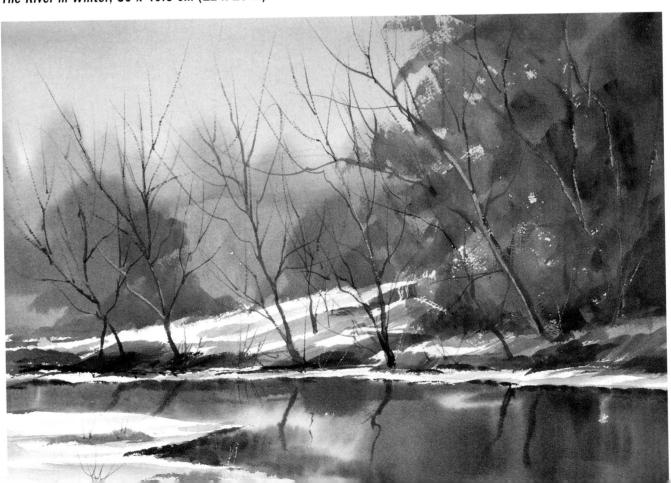

PROJECTS: Water

Water encompasses so many forms, from still, reflective surfaces to foaming waterfalls, that it provides a variety of challenges to the artist's technical capabilities, often within just one picture. Here I have picked photographs of the three types of water you will encounter most often – the relatively calm waters of an estuary, gently rolling waves on a seashore and a fast-moving, rocky river. As usual, remember that your goal is to give a free interpretation of the scene and avoid falling into the trap of trying to reproduce every wave, reflection and ripple. You can see my interpretations of these photographs on pages 120–2.

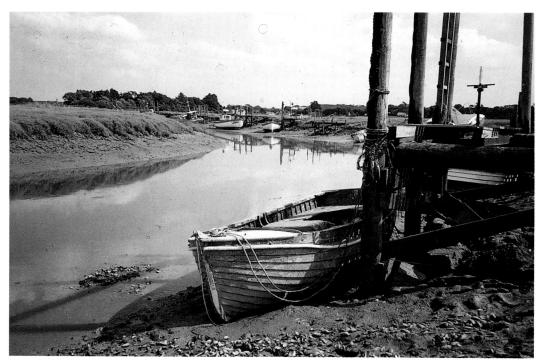

▲ This photograph has a pleasing L-shaped composition, albeit too heavy on one side. I also like its depth and tranquil atmosphere. However, the upright posts are distracting and there is nothing on the left to balance the mass of the boat and dock, so you will need to improve the composition. While the sky lacks interest, it gives you the

chance to use cloud forms to provide balance. One of the main problems in this type of picture is avoiding monotony or muddiness in the dark dock structure. One method is to use various mixes of blues, browns and light red. The beach too needs varying colours. Try for translucent shadows, allowing the underlying colour to show through.

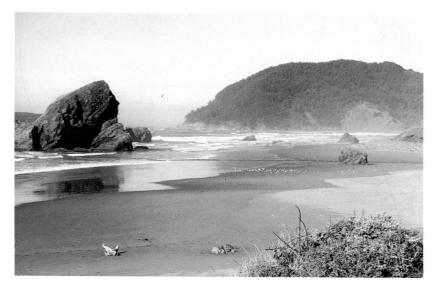

✓ I took this photograph during one of my workshops on the Californian coast. I feel that the scene needs unification, so try overlapping the main rock against the background hill to achieve this. You might also wish to introduce a figure or two to give scale and human interest, but take care where you position them or they will distract attention from the rock, which is the main focus of interest. Again, put plenty of colour into the foreground beach.

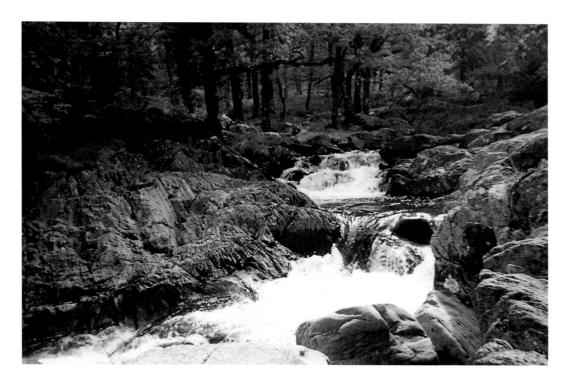

▲ I took this exciting photograph in North Wales. The star of the scene here is the foaming white water, so avoid leaving white paper anywhere else or you will detract from its impact. The rocks in the immediate foreground should be separated in order to allow perspective on the river. Introduce as

much colour into the rocks as possible, experimenting with blues, browns and ochres, and don't be too influenced by the relatively uniform colour in the photograph or you will limit yourself. Never try to put in rocks such as these stone by stone – what you are after is the overall effect.

FLOWERS

Of all the subjects covered in the book, flower paintings probably give you the most control over the design and composition of your photographs. Often you will be photographing flower arrangements indoors, with

no problems of telegraph poles, electricity pylons, rubbish dumps and the like; you will not be soaked by rainstorms or frozen in snow, so this will be your chance to concentrate on producing a really good photograph.

SETTING THE SCENE

It won't do to stick some flowers in a vase and take a snapshot – you must design your setting. Think of the background, the surface, the container and, most importantly, the lighting.

Look for harmony of colour in the flowers, particularly in a formal arrangement. Remember to consider the proportion of flowers to container as well as the type of container. Choose little jars or glasses for such small wild flowers as primroses, and stylishly shaped vases to echo the elegance of long-stemmed roses. Baskets, coffee pots and jugs can all be pressed into service, as long as they are right for the flowers they are going to contain. However, don't allow the container to dominate. The stars of this scene are the flowers.

In arranging your flowers in their container, try for a natural look. They don't need to be perfectly balanced, but you will obviously not want them to look as if they are about to topple

over to one side. Don't position your flowers so that the light hits them all equally – in strong light they may look flat, and in shade they will appear dull. Try to arrange lighting that will illuminate some flowers while leaving others in shadow.

To get the best effect from your flower paintings, you need to keep both the background and surface undemanding. Anything you put in must enhance your flowers, not distract from them. Backgrounds can vary in tone, enabling you to put light flowers against a dark part of the background and vice versa. A reflective surface such as a polished table can be used to advantage to unify the painting.

Once you have decided on your flowers, lighting, container, surface and background, consider whether or not another object on the surface might enhance your composition. Perhaps a book or favourite piece of driftwood carefully positioned might be just what is needed.

APPLYING DESIGN PRINCIPLES

Now, take a careful look through the viewfinder of your camera and make sure that you have applied the principles of design to your floral scene. Aim for informal balance between the flowers and the surrounding objects. The worst mistake you can make is to position the flowers in the exact centre of the scene. Move them to one side, using a less dominant object for balance. The

Iris and Jasmine, 28 x 21.5 cm (11 x 8½ in)

I loved the deep, rich blue of these irises against the purity of the white jasmine. In a loose, fresh watercolour the aim is always to convey a general impression of the flowers rather than to execute a tight copy of each flower. I could have masked out the jasmine before starting to paint, but felt that in this case using white gouache would work better. The rigger is ideal for fine stems.

▼ Below are four colours that are particularly useful for flower paintings, shown full strength and watered down.

Permanent Mauve

Cadmium Orange

thought that you put into creating your floral scenes is all good practice for general design.

EXPERIMENTING WITH COLOUR

Once you have a perfectly composed photograph you have to start the thinking process all over again. You are not attempting here to produce perfect botanical specimens with every petal and stamen in place, but to paint a free, fresh watercolour that will capture the freshness and beauty of the flowers in your arrangement.

One thing I find helpful in this respect is to use my polishers' mop with its superb point, which allows for delicacy without encouraging overworking. The hake comes into its own again for backgrounds and surfaces, while the rigger is reserved for stems and delicate foliage. I stay mainly with my seven usual colours (see page 13), but sometimes add Cadmium Orange, Cadmium Red, Permanent Mauve and Permanent Rose to my palette.

All the principles of design apply

Your overall principles should be to paint your floral scenes using a minimum number of brush strokes and seeing the flowers as patches of colour rather than arrangements of petals. This will portray the freshness, delicacy and beauty of your flowers better than a photograph ever could.

Permanent Rose

Cadmium Red

▲ Here you can see the effect of first dampening the paper and then dropping in various pigments which are allowed to intermingle with each other. This might be a good way in which to start your flower painting, introducing stronger, richer colour as the paper dries.

◀ Here the method of dropping pigments in to damp paper is shown in practice. The colour was dropped in wetinto-wet and allowed to diffuse. As the paper dried, strong, sharp strokes were introduced, using the pigment almost neat.

Bluebell Wood

Although flowers in the wild don't allow you the same opportunity as indoor arrangements to compose a perfect photograph there is something special about seeing them growing in their own habitat which more than compensates for that.

THE PHOTOGRAPH

I couldn't resist taking a photograph of these bluebell woods near my home – the swathe of colour beneath the trees each spring is always a delight. Woodland photographs can be tricky because shafts of light shining between the trees can mislead the camera's light meter. Also, you will often have to include more tree trunks than you will wish to put in your painting.

THE PAINTING

The challenge was to convey the massed flowers without overworking. The most difficult part was the foreground, with its mixture of greens and blues. I changed the lighting to give more interest in the tree trunks and pared down the number of trees. The figure of the little girl adds life and provides a centre of interest.

Bluebell Wood, 27 x 38 cm ($10\frac{1}{2}$ x 15 in)

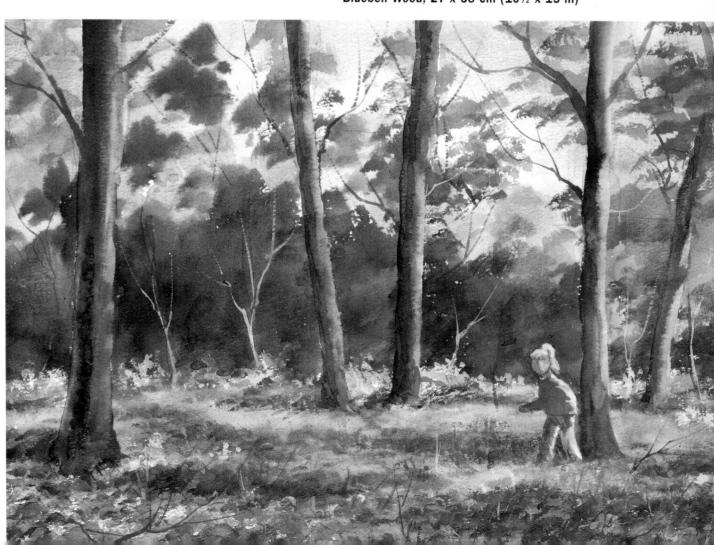

Yellow Roses

This is an example of the way my 'fast and loose' techniques can be applied to flower painting. No attempt is made to be botanically correct. The aim is to produce a free, fresh painting, pleasing to artist and viewer, giving a good general impression of the flower arrangement.

THE PHOTOGRAPH

This charmingly informal little flower arrangement was well beyond its peak of perfection, but I thought that it would make a good subject for a fast, loose painting so I decided to photograph it anyway. In all I took three photographs, placing the vase experimentally in different lights, such as in front of a window and in full sunlight on the garden path. The photograph where the flowers were illuminated strongly on one side by window light seemed to me to be the most satisfactory of the three. When I arranged the flowers I aimed to get as much contrast as possible between the light tones of the yellow flowers and the darker leaves.

THE PAINTING

The temptation with a subject such as this is to try to copy every leaf and petal, which would produce

much too tight a painting and be very inhibiting. I merely sketched in the main shapes of the flowers, allowing myself plenty of freedom of expression as I did so. I painted quickly, using my polisher's mop, and putting in plenty of counterchange to produce sparkle in the finished painting. The individual petals of the roses were merely hinted at with the point of the polisher's mop, as the more economically these are portrayed the better.

Yellow Roses, 20.5 x 23 cm (8 x 9 in)

Sunlit Daffodils

As in all my flower paintings, my aim was to convey the general impression and colour of the flowers, rejecting any attempt to paint each one individually.

THE PHOTOGRAPH

This photograph was taken at home in my dining room. I felt that the dark, shiny table made a good foil for the bright yellow of the flowers. I emphasized this contrast by

using the strong daylight from the window coming in from the right. I also wanted to give an impression of some of the other items in the room, such as the distant lamp and the potted palm. I decided that standing the vase of flowers on the small silver tray gave a more formal air to the flower arrangement, in keeping with the setting.

THE PAINTING

When I looked at the photograph I could see that the complex shape of the chairs was a distraction so I left them out of the painting entirely. The potted palm and table lamp were merely hinted at, while the table top was painted very much wet-into-wet, using a variety of colour. The rich surrounding dark tones point up the joyful colour of the daffodils and give them form and substance. Again, no attempt was made to paint in individual blooms. I felt that all that was necessary was to indicate the overall shape of the arrangement, with just an occasional suggestion of a trumpet here and there to identify the flowers beyond doubt.

Sunlit Daffodils, 24 x 19 cm $(9\frac{1}{2} \times 7\frac{1}{2} \text{ in})$

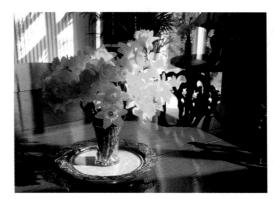

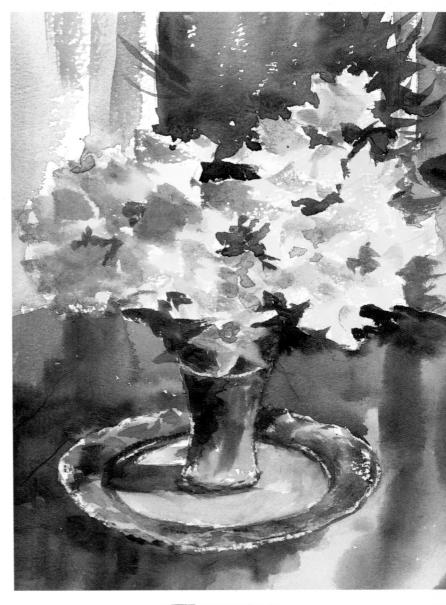

PROJECTS: Flowers

When you are painting from these photographs it is even more important than with most other subjects to avoid the temptation to copy every detail – it simply won't work. Do just a rough pencil sketch of the general arrangement, because if you make a more detailed one you will tighten up too much when you move on to the painting stage. Make use of the hard and soft edges that are characteristic of flower subjects. Employing counterchange is another important principle to remember here; placing light flowers against dark leaves or backgrounds and vice versa will bring your paintings to life. See my interpretations of these photographs on pages 123–4.

■ There is plenty of variation of strong flower colour in this photograph, which may tempt you to be too precise in your rendition of the individual blooms. Remember to retain the fresh and loose brushstrokes that will give your painting life. You will need to lighten the flowers nearest the camera, which in the photograph are so dark that they can hardly be distinguished; if you were to reproduce this in your tonal sketch you would see that it would make for an unbalanced painting. Adding a few extra flowers on the left-hand side will also help to provide balance. What with the ashtray, the glass vase and the window, there is plenty of reflection in this picture - but don't be tempted to convey the cut-glass effect of the vase as this would distract the eye from the flowers. Again, keep your interpretation free to give just an impression of the lightness and airiness inherent in such reflective surfaces.

I took this photograph because I loved the effect of the bright colours of the roses counterchanged against the rich, dark colour of the smoke bush leaves. Try painting this using a wetinto-wet background, gradually using stronger and richer colour as the paper dries. Remember that you only need to indicate the petals of the roses with economy of stroke. The best way to handle the clear glass vase is to repeat some of the colour from the foliage to give the painting unity.

■ When I saw this beautiful, richly coloured vase in a shop I couldn't resist buying it! When I got it home I filled it with a variety of silk flowers, which these days are very true to life. The object here is to convey the impression of the multitude of small blossoms, and again wet-into-wet technique would work well. Rigger work and stronger colour could be added once the paper has dried. You will need to work fast and decisively.

FIGURES IN THE LANDSCAPE

When you look at a watercolour scene you may often have a feeling there is something missing. On analysis you realize that what is lacking is a figure, either human or animal. Scenes of boatyards,

beaches, streets and markets all look rather desolate without figures – which is fine if that is the intended effect, but it is more likely that the artist may have been afraid of spoiling the landscape by putting them in!

LEARNING TO PAINT FIGURES

You don't need life drawing classes to teach you how to paint figures in your landscape, but you do need to follow a few simple rules and you do need practice. Next time you're out and about with your camera, try for some scenes that include people or animals. Take your sketch book along too, and try to jot down quick impressions. Don't bother about reproducing detail – just concentrate on movement, areas of light and dark, and linking your figures together in pairs or groups. Even if the photograph you are using does not have figures in it, put them in your painting if you feel they are needed; they will give it life, movement, scale and variety. They can also be very useful to provide a main object of interest in a scene, but if you do employ them in this way keep them at a different distance from each edge of the painting.

SCALE AND COUNTERCHANGE

Size of figure is important, of course, and many of my students seem to find this a problem. It's all a question of scale. A figure of a certain size placed in the foreground would look ridiculously small, but place that same-sized figure further back and it would look like a giant. One way of overcoming this problem is to draw the figure on tracing paper, then move it around your drawing until it looks right. When it does, it is in the right place. If your figure is near a doorway or a dinghy, scale is fairly straightforward - the figure shouldn't have to get down on hands and knees to get through the door, and must be the right size to sit in the dinghy!

Make sure that your figures are counterchanged, placing light figures against a dark background or vice versa. Use the device of painting dark trousers and white shirt against light and dark backgrounds respectively for effective contrast of tone

KEEP IT ECONOMICAL

Once you've become used to putting figures in your paintings, you will be surprised how little work you need to do on them as long as the basic proportions are right. In a café scene, for instance, a few colourful splashes under an awning, accompanied by a few strokes for legs, is sufficient. Your viewers will fill in the rest for themselves. It may encourage you to know that an artist friend of mine used to avoid putting

Cliff Path, Kalymnos, 35.5 x 28 cm (14 x 11 in)

There were no figures in the photograph I used as reference for this painting - I added them to draw the eye of the viewer into the picture. counterchanging the tops of the figures against the dark background. The distant outcrops needed to be out of focus, so I painted them wet-into-wet using combinations of Light Red, Ultramarine and Raw Sienna. As I moved forward in the scene I put in more contrast and warmer, richer colours.

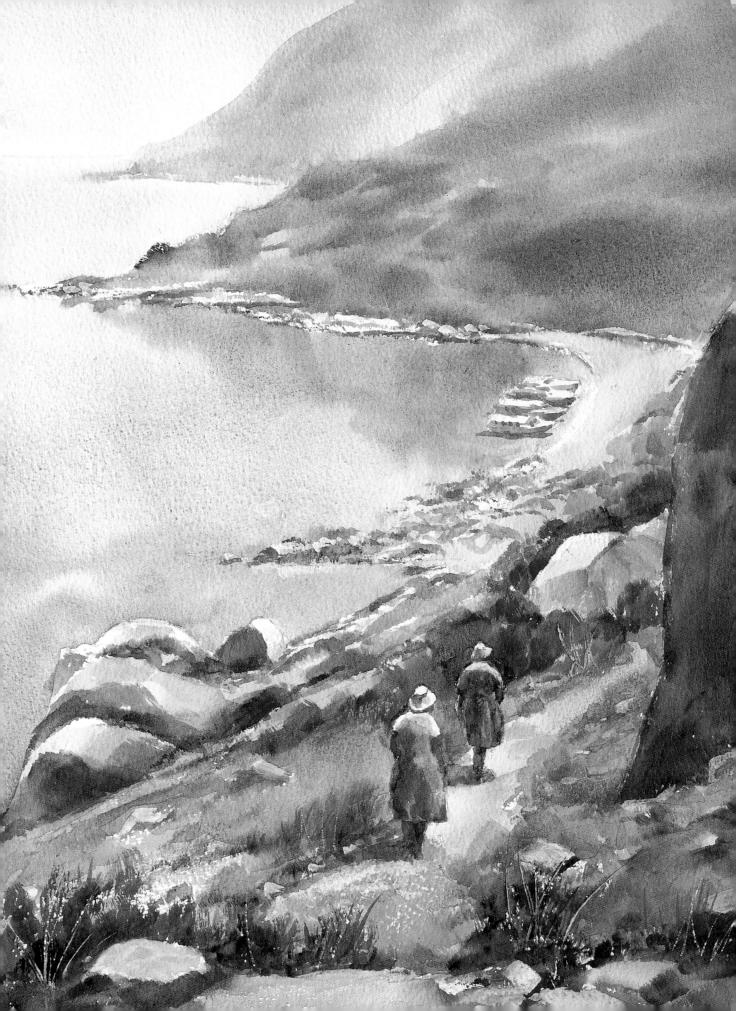

figures into his paintings. Having once discovered just how simply and economically they could be indicated, he now seeks out populated scenes, which he portrays with tremendous vigour and simplicity.

The problem you have to overcome is the fear of putting in figures, rather than any lack of ability. A few days with a sketch pad will soon overcome this and you will be producing livelier and more authentic paintings.

A photograph of an everyday scene in town can be a very useful reference for painting figures in the landscape; they can be transplanted into any scene that requires some human interest.

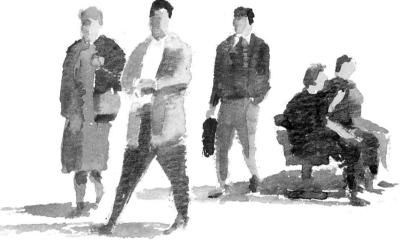

Here I have extracted a few figures from the scene on the left and moved them around. I have also simplified them – putting features on faces, for example, is not necessary.

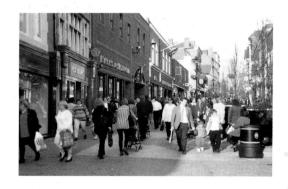

This is a typical urban scene of a busy high street, with families out and about doing their shopping. Notice the proportions of the figures in relation to the buildings.

The figures in this scene have been drawn direct from the photograph on the left. Even with no background, the viewer would guess that they are in urban surroundings.

In the countryside you will be able to photograph figures engaged in rural tasks and leisure pursuits that you can use for reference. Notice how in each of these illustrations shadows are used to anchor the figures on the ground and link them with each other.

TIPS FOR PAINTING FIGURES

Do keep your figures simple – they can be very roughly indicated as long as the proportions are right.

Do keep heads small and figures tall and elegant.

Do make your figures an integral part of the scene.

Do forget about feet – they are not usually necessary.

Do give shadows to your figures whenever possible – they help to anchor them.

Do remember counterchange and scale.

Don't put your figure or group of figures in the middle of your painting.

Don't forget to make a pair or group of figures a single unit, with a single shadow.

Don't make your figures stand to attention – give them a natural stance.

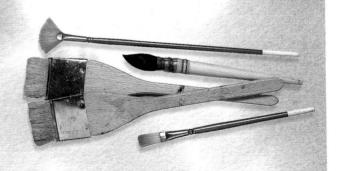

Market Square in Orta, Italy

An urban scene that would be static if uninhabited springs to life once some human figures are included. This demonstration shows that even lightly suggested figures are quite sufficient to make a crucial difference to the feel of the painting.

THE PHOTOGRAPH

This photograph of a street market was taken in the ancient town of Orta in Italy. It's a typical Mediterranean scene with mellowed buildings, shuttered windows and people strolling between market stalls. I felt it would make a pleasing composition for a watercolour with hardly any alteration necessary. Notice that the foremost building has been framed off-centre.

THE PAINTING

I made some minor changes such as omitting the girl partly out of frame on the left and correcting the verticals on the building behind her, but apart from that it was just a matter of simplifying the scene.

Although the figures have been pared down to the essentials – indeed, only the foreground ones even have feet – they still retain movement and purpose. The faded mural on the main building has been merely suggested by some areas of warmer colour. This scene would lose all its vitality if the figures were omitted.

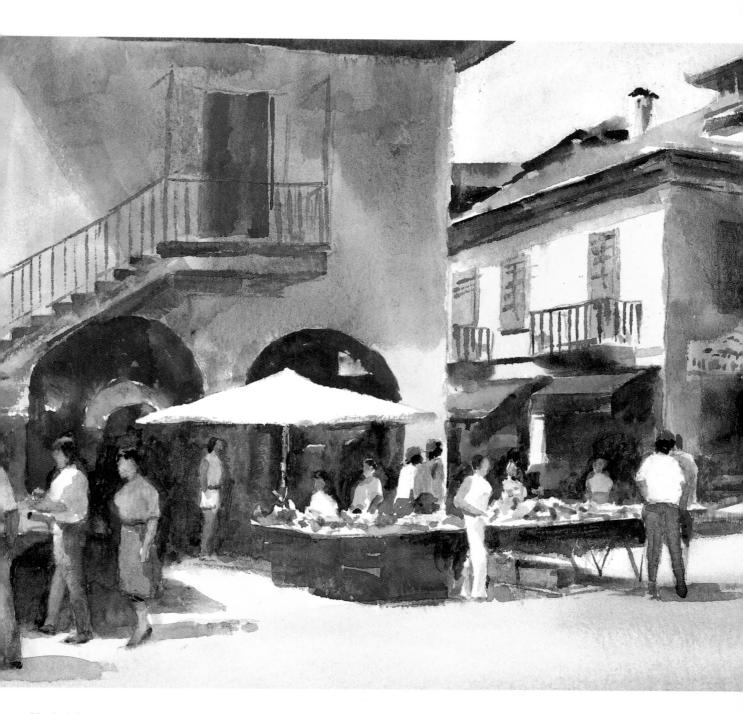

Market Square in Orta, Italy, 19 x 28 cm ($7\frac{1}{2}$ x 11 in)

PROJECTS: Figures in the Landscape

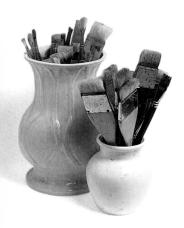

These photographs offer you a variety of populated scenes to use as the basis for paintings that include figures. In this project your whole objective is to try to simplify the image while still retaining all the action and movement – in effect the same approach that you have adopted throughout the book, for even when painting static subjects such as flowers the aim has been to express their freshness and life. On the whole, you can forget about painting any facial features on your figures and often you can even omit their feet. Think of the figures as part of the overall picture, not as an add-on using a different technique. My paintings from these photographs are on pages 124–5.

► Each year I set up camp in a beautiful spot in the mountains of Oregon with our multitudinous family. In this instance the grandchildren were running about wildly, so I snatched some hasty photographs of them. Your task here is to select some of the figures and transpose them into a painting.

■ This is a photograph I took on a busy Saturday afternoon in Windsor – you can see the famous castle in the background. Your chief aim here must be to simplify the scene as much as possible, particularly of course the buildings themselves, by restricting yourself to using a 25 mm (1 in) flat brush. In this way you will be able to retain the bustling atmosphere.

I took this photograph during one of my workshops in Venice. Try to convey the bustle and life of the scene without including too much detail. The yellow of the flowers will provide pleasing colour in the foreground which can be picked up again further back in the scene. The figure of the man on the right is rather lost against the background, and you will need to address this.

BUILDINGS

in a woodland scene, being content to take the viewer into partnership and allowing him or her to do some of the work, they don't seem able to apply the same attitude to buildings. Instead they feel they must paint in every window and door, even every brick, and the painting loses all vitality.

KEEP YOUR PAINTING FREE

I once took a group of students to Venice for two weeks. The group included four architects, who for the first week produced accurate and detailed drawings of the city. It was not until the second week that I convinced them that it simply is not necessary to put in every window, and that they were missing the general ambiance of old warm stone with varying colours. Once they had got the message they turned out loose, impressionistic paintings that captured all the atmosphere of this wonderful and ancient city and really started to enjoy themselves.

I have never made any secret of the fact that the greatest influence on my work has been from Edward Seago. I've spent many hours studying old exhibition catalogues of his work, marvelling at the way he was able to suggest buildings, especially Venetian

ones, with such economy and freedom. I've always tried to apply Seago's approach to my own work, but I still sometimes have to fight the urge to overwork.

One device that may help you to keep your buildings loose and impressionistic is to limit your time, remembering that unlimited time is likely to result in unlimited detail. Another is to restrict your brushes to the 25 m (1 in) flat for such things as windows, roofs, doors, chimneys and balconies, as these are the danger areas in terms of overworking. When I'm painting in Greece I find that I can suggest a whole village with a few strokes of the 25 mm (1 in) flat, and I employ this same technique when painting from photographs; the flat edge can be used for roofs and balconies, while the corner suggests windows. It positively prevents you from being too fiddly. Lock your No. 2 sables away in a cupboard!

ADAPTING THE PHOTOGRAPH

This temptation to overwork is probably at its strongest if you are working from photographs because you have more time to put in unnecessary detail, and will be inclined to copy the colour in the photograph as well. However, to avoid the portrayal of boring buildings, you have to put in a good variety of colour which could not be apparent in a photograph. One of the questions I'm frequently asked is 'What colour should I mix for a local stone wall?' In fact, you

Back Canal in Venice, 40.5 x 28 cm (14 x 11 in)

The big challenge in this scene was to create all the atmosphere and colour of the buildings while avoiding the temptation to overwork. I varied the colour of the buildings using a hake before turning to my 25 mm (1 in) flat brush to put in, very economically, architectural details such as doors and windows. Using this brush makes it almost impossible to put in unnecessary detail such as individual bricks. The viewer's imagination will supply as much detail as is needed.

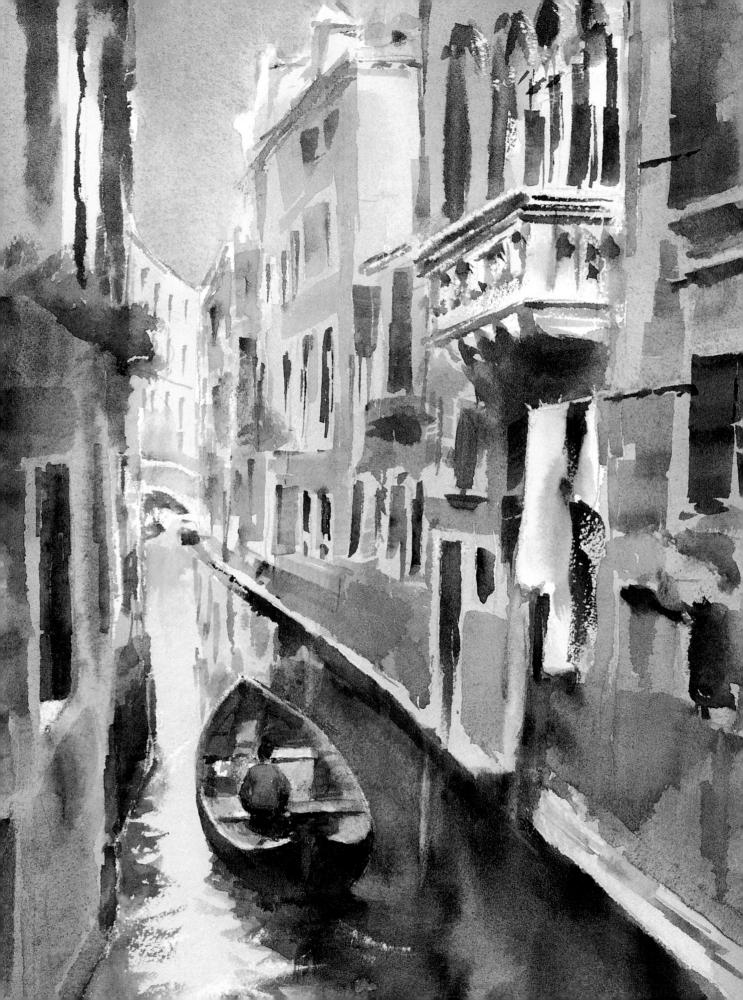

▲ To convey a sense of distance, put in the windows and doors of a building while the wash on the wall is still damp to produce an out-of-focus effect or just leave some of them out altogether.

► Shadows on buildings are important, as they help to convey the surface shapes as well as form. However, they must always be painted in a transparent and spontaneous way, allowing the original wall colour to show through.

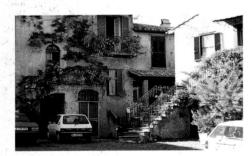

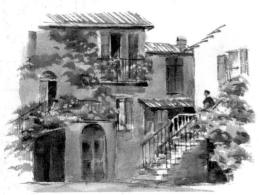

■ The little vignette below shows how you can take out cars, add people and use foliage to soften a painting. Notice how I have attempted to get more colour into the walls. The blue flowers were put in last, using white gouache mixed with Ultramarine watercolour.

add colours as you go along; blues, reds, browns and ochres are all needed to produce the right effect.

In photographs the verticals of buildings are often distorted. This must be corrected in your drawing before you begin to paint – while a window need not be detailed, it must be straight! An important point I learned from Seago is to put in some of the windows before the paint on the wall is quite dry. This gives an out-of-focus appearance which is very effective in distant buildings.

SHADOWS AND LIGHT

In photographs of buildings you are likely to have strong shadows, which often look opaque and dead. In a watercolour they must be transparent, showing the underlying colour. However, if you have taken your photograph on a dull day it may not show much difference in the tones of the various surfaces, which makes for a flat, boring picture. Your tonal sketch is where you correct this, dramatizing and harmonizing the lighting, adding shadows to make the picture more exciting. Exploit each shadow to describe the surfaces and planes it falls on but simplify, organize and exaggerate the tonal values in order to make them more 'fast-reading' for your viewer.

It is best to paint all the walls of a building together, dropping in a darker transparent wash to the shadowed side after the first wash has dried. If you paint in dark and light areas separately, you will end up with a patchwork effect. Another change you will often have to make is to darken the sky to pick out the profile of the buildings – in other words, use the sky to create negative shapes.

Greek Island Village

Your photographic viewpoint of buildings may often be blocked by vegetation, lorries or building work. Take the photograph anyway, for, as this demonstration shows, it is easy to make adjustments when it comes to the painting.

THE PHOTOGRAPH

This scene was taken on a painting holiday in Kalymnos. I felt that the right-hand side seemed heavy and dead, with the dark wall and the foliage providing a looming presence that detracted from the inviting feel of the simple white buildings.

THE TONAL SKETCH

In the tonal sketch I corrected the imbalance by lightening the wall and reducing the weight of the foliage. I made the balcony on the left-hand

house the focal point by putting some figures on it, and used the perspective of the righthand wall to point to it.

THE PAINTING

I felt this needed more skyline to define the terrain and I also wanted to get as much colour as possible into the barren hillside. I continued the changes I made in the tonal sketch to lighten up the whole picture on the right. Finally, notice the variety of colour I have put into the white walls.

Greek Island Village, 30 x 40.5 cm (12 x 16 in)

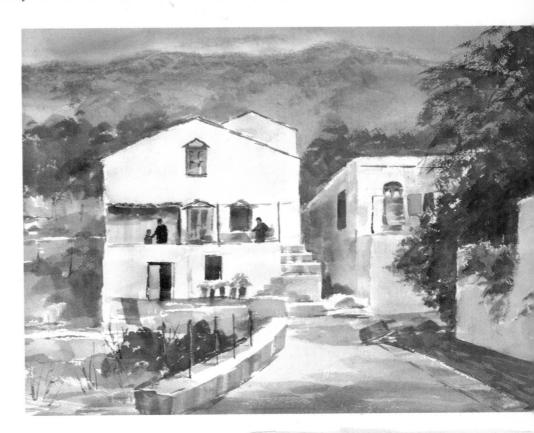

Market Cross at Malmesbury

In many towns you can find old buildings islanded in the midst of modern life. While the temptation may be to eliminate the new, the danger is that you may produce a 'chocolate box' painting. Instead, opt for a selective view that celebrates the old while presenting a truthful picture of the scene.

THE PHOTOGRAPH

I took this shot during one of my workshops in this delightful old town in Wiltshire. While the relation of the buildings to each other makes a satisfactory composition, there are intrusive details that distract the attention from the main focal point of the picture – the old cross.

THE PAINTING

Although the market cross seems a complex structure to paint, I've managed to give a good general impression without too much detail by using the edge and corner of the 25 mm (1 in) flat. While wanting to preserve the liveliness of the scene, I cut out some of the modern paraphernalia of cars, white and yellow lines on the road and the blackboard menu for the restaurant. It often helps to add a few touches of bright colour just for fun and cars can usually provide that, so I did include a few, indicating them very simply. I decided to add some more cloud to the sky and put in a few very loose figures to enliven the scene and add to the atmosphere.

Market Cross at Malmesbury, 25.5 x 30 cm (10 x 12 in)

The Hill in Orta, Italy

Tiled roofs and cobbled streets are appealing as you wander round a town and make for an interesting photograph to look at afterwards – but in an impressionistic watercolour you should not make any attempt to pick them out in detail.

THE PHOTOGRAPH

I spent two weeks teaching in this lovely old town facing the lake and took a number of photographs of its quaint cobbled streets with their mellowed buildings bright with pot plants. The contrast of light and shade here has confused the camera's light meter so that the sky and water have been bleached almost to white, losing some of the charm of the view down the street.

THE PAINTING

More colour was needed here than is apparent in the photograph, even in the shadowy area on the right. The

eve is directed down the hill to the distant lake, so I've removed the distracting figure of the woman coming out of her gate on the right and contrasted the sunlit house against the lake, which in the painting has regained the blue reflected from the sky. It is easy with this type of scene to become distracted by the cobblestones and paving and so miss the point of the picture; just a suggestion of a rough surface will be quite sufficient. Notice that to restore balance and add interest I have added a couple of windows to the house on the right which in the photograph have been blocked up.

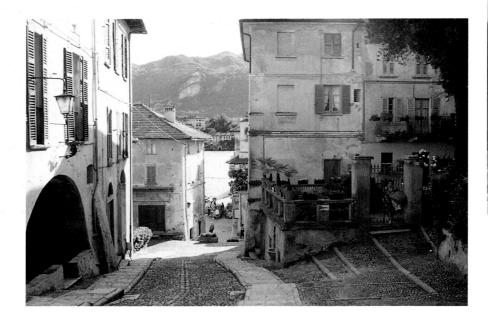

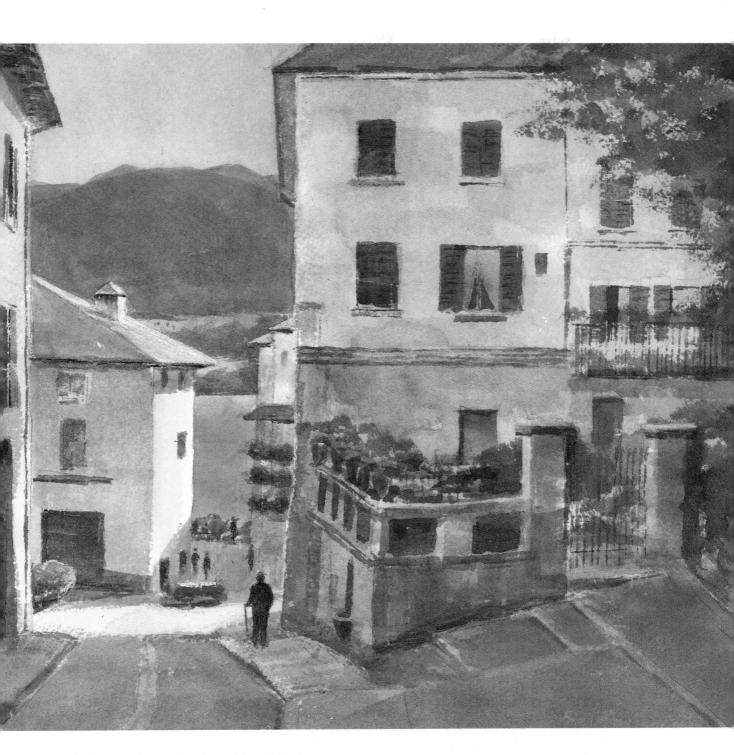

The Hill in Orta, Italy, 25.5 x 30 cm (10 x 12 in)

PROJECTS: Buildings

The 25 mm (1 in) flat brush will be your best ally in producing a free, fresh approach to the painting of buildings, helping you to avoid the temptation to put in too much detail. Make a special effort to get more varied colour into the walls than you see in these photographs, otherwise your paintings will look dead; the flat, uniform colour that you take for granted in a photograph will not be at all satisfactory in a watercolour. Remember always to do tonal sketches before embarking upon your final paintings and make any changes you feel will enhance the composition. This is your chance also to enhance tonal values to give the paintings plenty of definition and visual interest. You can find my interpretations of these photographs on pages 126–7.

▲ I took this photograph on a beautiful sunny morning in Bath, noted for the glorious colour of its stonework. Your task here is to convey the busy architecture without becoming bogged down in too much detail – the 25 mm (1 in) flat brush will help here. Try

putting in windows using just the corner of the brush. You will probably need to mask out the church steeple. The trees on the right provide a good foil of soft, free texture against the architecture of the bridge. The hake and the rigger should be used in portraying the tree.

◀ I was asked to run a painting course in Muscat, Oman, and this photograph was taken in one of the city's narrow back streets. Your first thought on how to translate this into a successful watercolour painting should be to put more varied colour into the walls and ground, as sticking faithfully to the colours in the photography will produce a dull painting. A robed figure might not go amiss to give human interest to the scene – but remember to take great care as regards the position and scale of the figure. Try to retain the atmosphere of antiquity in your painting.

◄ This is a corner of Venice's fish market. You will need to convey its bustle and colour, perhaps by adding more activity – the photograph was taken at a quiet time of the day. The elaborate architecture must be painted in the simplest possible way. The water could be made more interesting by adding reflections and the sky darkened to give the buildings a stronger profile.

THE FOUR SEASONS

This chapter is something of a new challenge, because what I'm asking you to do here is to change the season that is portrayed in your photograph to quite another in your painting. You can choose to turn winter to

summer, autumn to spring – whatever appeals to your imagination. It will mean altering the whole colour scheme and atmosphere of the painting – quite a tricky enterprise, while finding the skeleton of a winter tree beneath the enveloping leaf canopy of a summer one can be downright difficult.

In this chapter I have shown you some examples of my own to set you off on the right track. Don't be daunted by these exercises – they can be great fun to do. Here more than ever you should always do a tonal sketch before embarking on a painting, though, because the whole pattern of the scene may need to be completely altered.

CHANGING THE PALETTE

In the summer and spring, you will generally have a varying range of greens – cool, bluey greens in the background and rich, warm greens in the foreground. In autumn the distant trees will require mauves, and for the closer ones you'll need to employ light reds and browns. In winter distant trees become subtle greys, with a stronger mix of browns and blues coming in as you move towards the foreground.

Snow scenes are great fun to paint. You'll have a much stronger, more contrasting pattern to your picture, with the shadows being mainly blue on the snow. Winter scenes require plenty of practice with the rigger for authentic portrayal of delicate bare branches and twigs.

SUBTLE SEASONS

Autumn and winter are seasons when you can use the subtle effects of mist to create atmosphere. Here, of course, the tones of the various layers of the landscape vary even more. While your foreground objects will be dark and crisp, anything in the background will be painted very much wet-into-wet, employing subtle tones. The whole operation gives you a real chance to exercise your imagination, and you will be surprised at the interesting effects you will achieve.

Woodland Stream, 40.5 x 30 cm (16 x 12 in)

I photographed this woodland river scene in Devon in summer (below). When I came to paint it I decided to change the season to winter and make it a cold, misty scene. The colours therefore needed to be changed from various greens to greys, browns and mauves. Mist is an ideal subject for watercolour as it lends itself so well to wet-intowet treatment.

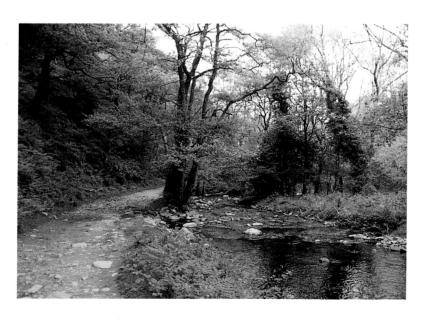

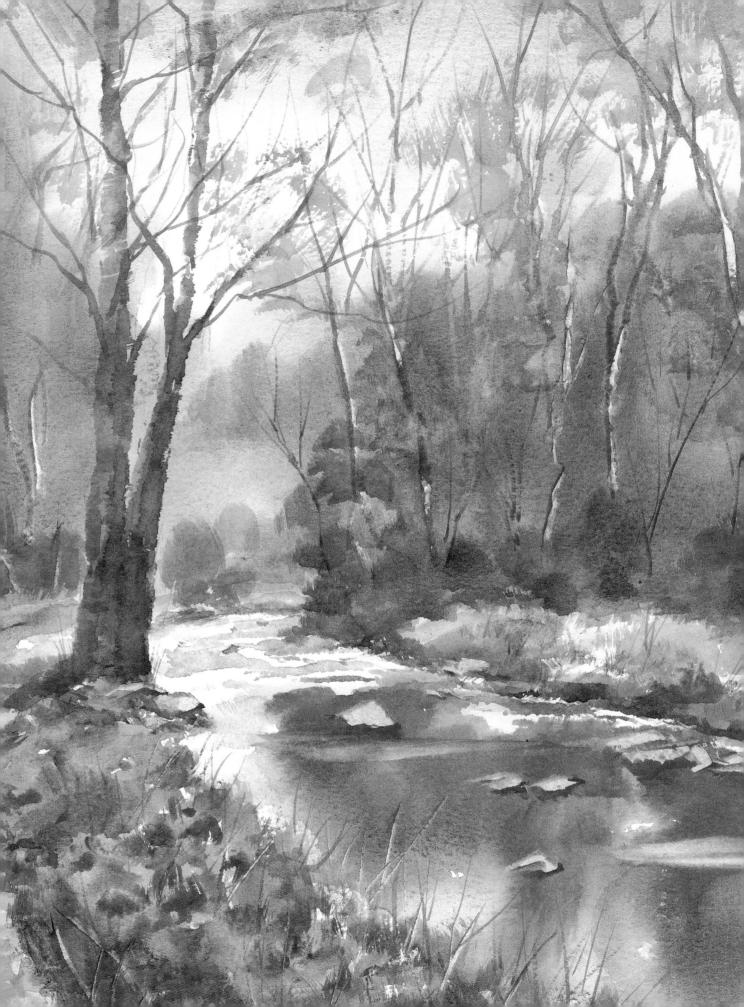

The River Wye

Here a summer scene takes on the browns and mauves of autumn and also the chilly whites and blues of a snowy winter's day.

THE PHOTOGRAPH

This is one of my favourite painting spots on the River Wye near my home. The photograph shows it in the placidity of a summer day.

THE PAINTINGS

I have painted this scene in many different weather conditions and here are three of them. The painting shown right mirrors the scene in the photograph, with all the varying greens of summer. In the snow scene (far right, top) I've restricted myself to blues, browns and greys and used

the rigger much more to indicate the bare branches. Notice that I have made no attempt to pick out the branches of the trees in the middle distance, merely depicting them in a mass of colour stronger than those in the far distance. In the autumn scene (far right, bottom) the distant hills have more mauve, complemented by the rich browns and ochres of the foreground. In each painting the colours are diluted in the background and rich in the foreground to give a feeling of recession, and the different sky colours are reflected in the water.

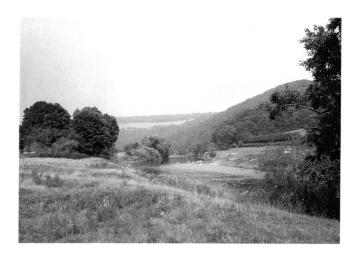

The River Wye - Summer, 30 x 40.5 cm (12 x 16 in)

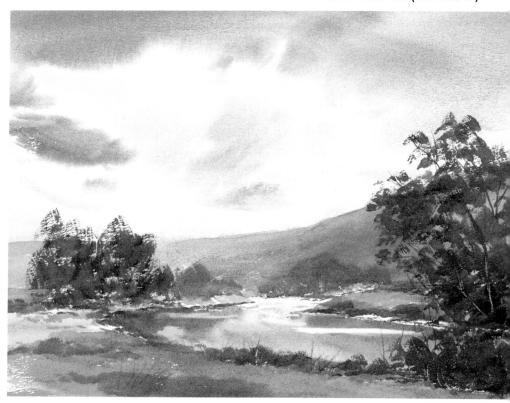

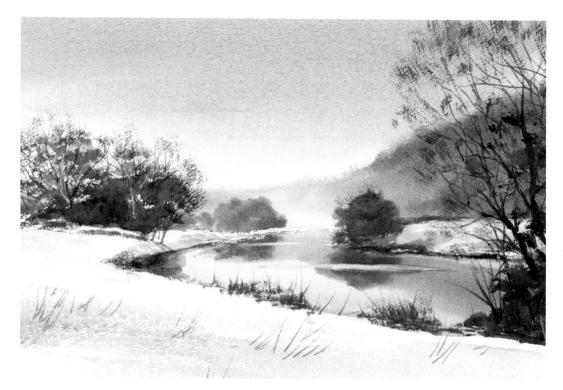

The River Wye -Winter, 30 x 40.5 cm (12 x 16 in)

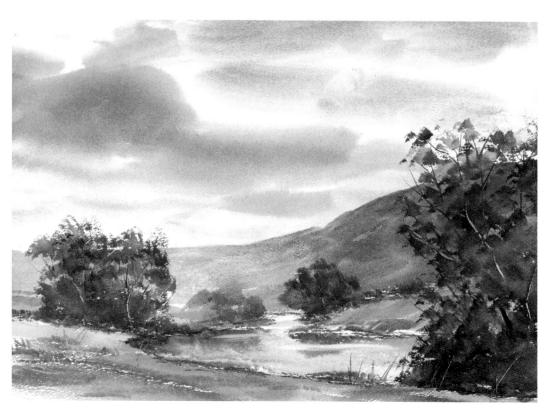

The River Wye – Autumn, 30 x 40.5 cm (12 x 16 in)

River Mist

By changing the composition as well as the season you may end up with a painting that is very different to the photograph you used as your starting point. Such experimental treatment is an excellent way of developing your interpretive skills.

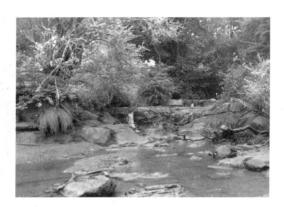

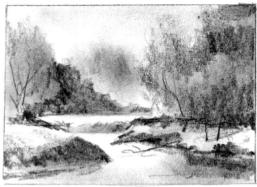

THE PHOTOGRAPH

This is a photograph I took in New Zealand. I liked the broad, smooth shapes of the rocks contrasted with the outline of the dead branches and the softness of the foliage, although I could see that to make a successful painting I would have to adjust the composition quite considerably.

THE TONAL SKETCH

In the tonal sketch I removed the rocks and mud in the foreground to allow the viewer access to the scene and created some sky in order to introduce depth of field. The scene immediately looked more three-dimensional. I also used some darker tones in the foreground and middle distance to provide contrast.

THE PAINTING

By changing the entire colour scheme from that of summer to autumn I have given the scene a far more romantic, moody atmosphere. The colours I used were Crimson Alizarin, Light Red, Ultramarine, Burnt Umber and Raw Sienna. Restricting myself to this limited palette has enhanced the feeling of harmony in the picture. I began the painting by laying a soft Raw Sienna wash over the whole background, gradually adding richer colours on top of each other while the first wash was still damp. I left various areas of the river as untouched paper to give sparkle and contrast. Notice the directional strokes of the hake to indicate the slope of the banks.

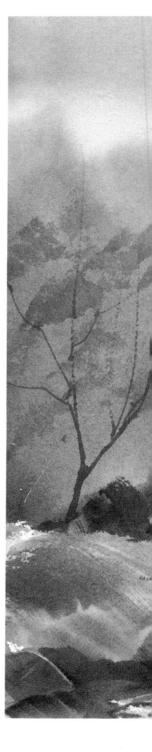

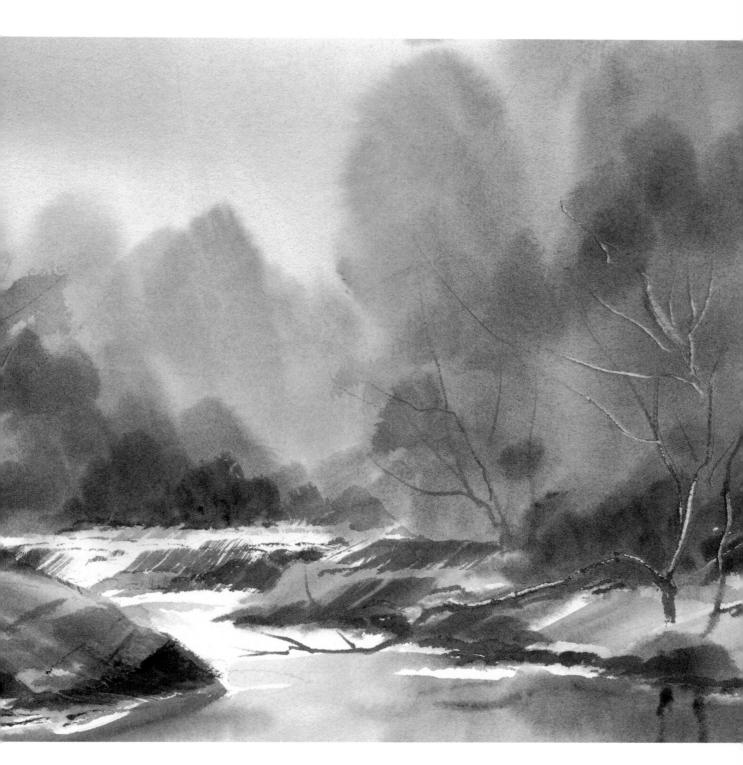

River Mist, 30 x 40.5 cm (12 x 16 in)

Shadows Across the Lane

In just a few weeks the changing of one season to another can cause a scene to look radically different from the one you have photographed. When you paint from your imagination, think about the alteration that the landscape has undergone.

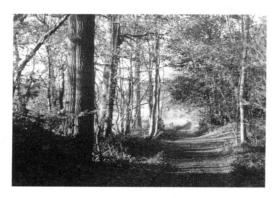

THE PHOTOGRAPH

Every autumn I used to teach at Phillips House, a lovely mansion near Salisbury, Wiltshire. I took this photograph on one of my earlymorning walks in the grounds. The sun cast long tree shadows which showed up the profile of the tiny lane. Notice that I have picked a viewpoint in which one tree is dominant.

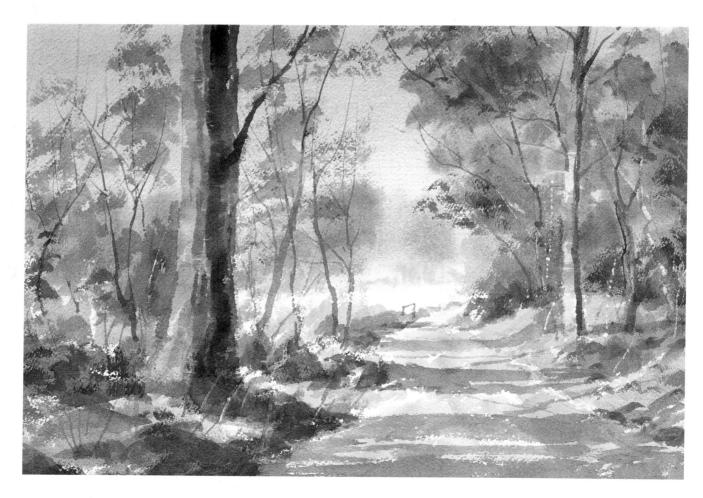

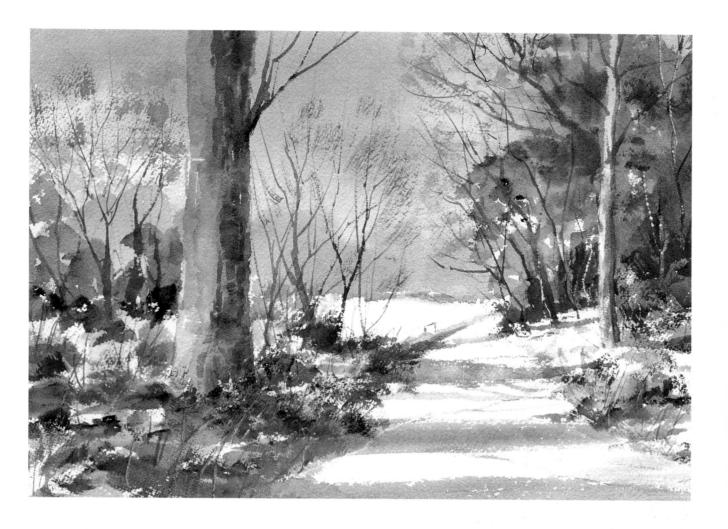

THE PAINTINGS

As you can see, I have made very few changes from the photograph in the painting on the left. By softening the background I've given the scene more distance to the end of the lane, drawing the viewer into the picture. The shadows stretching across the lane enhance the feeling of sunshine in the scene.

In the painting above I have imagined the whole scene under snow. With the leaves off the trees, much more rigger work was required to depict their skeletal branches. You will notice that I have softened the shadows and made them more blue,

rather than the mauve I used in the autumnal painting. I decided to add yellow to the sky, while the ground was left mainly as untouched paper with just a hint of yellow to reflect the sky and thus retain the unity of the picture.

What I wanted to do in both of these pictures was to capture the atmosphere of peace and quiet of a scene that always brings back many happy memories. Shadows Across the Lane – Winter, 30 x 40.5 cm (12 x 16 in)

Bigsweir Bridge

If you are particularly fond of a local view you will probably find that you paint it repeatedly at different times of year in any case, enjoying its nuances as seasons and weather conditions change. However, doing it from the imagination only is excellent practice.

THE PHOTOGRAPH

For 25 years I lived at the very top of the distant hill that looked down to this bridge spanning a slow-moving river some 180 m (600 ft) below. The photograph here was taken in very poor light in winter, so the overall effect is rather dull and monochrome – indeed, it could almost be mistaken for a black and white photograph.

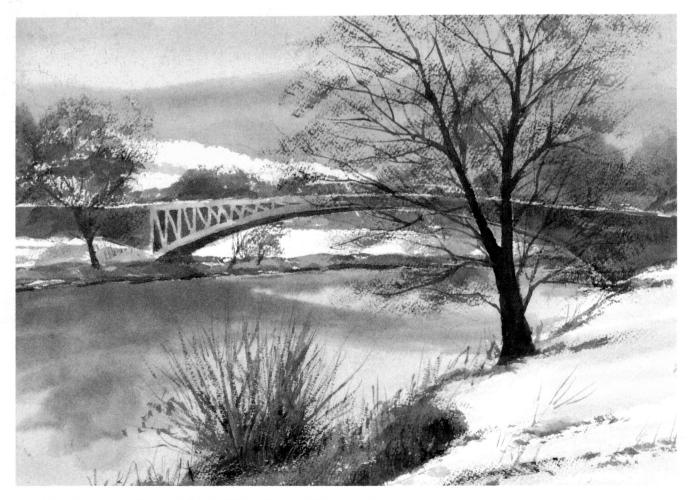

114 WATERCOLOUR LANDSCAPES FROM PHOTOGRAPHS

THE PAINTINGS

In the winter painting I have increased the contrast of tones and colours considerably. I love the spot and have painted it several times, but have always found the girders difficult to put in convincingly in a loose watercolour – in fact here I've managed to avoid them altogether on the right-hand side of the bridge! You'll notice the high waterline on the banks where the snow has been washed away.

In the second painting I've drawn upon the same photograph but this time turned the scene into a summer one, using various greens and putting a full leaf canopy on the trees. This exercise requires a good deal of thought and imagination but is very rewarding. As always, the river colour is a reflection of the sky, and the greens change from the cool bluegreens of the distant hills to the warmer colours of the foreground to create a feeling of depth.

Bigsweir Bridge – Summer, 24 x 33 cm (9½ x 13 in)

Bigsweir Bridge – Winter, 24 x 33 cm ($9^{1/2}$ x 13 in)

GALLERY

Travelling the world to teach watercolour painting gives me opportunities to see many different types of landscape. The drawback is that there is never enough time to paint them! What there is always time for,

though, is some photography, and by the time I arrive home in England I have numerous rolls of film.

Not all the photographs will be suitable for painting from, but I try to return each time with a higher proportion of good photographs – looking back at some taken a decade ago, I'm horrified at how little thought I put into the composition. As you make a practice of considering

composition for a painting you will find that you automatically begin also to frame your photographs with more care.

In each of the projects in this book I have given you photographs to use as a basis for a painting. What I want to do in this chapter is to show you what I had in mind when I took the photographs. I have made several changes in the finished paintings in order to intensify the original image and atmosphere. Study each spread, noticing the design and colour changes I have made and comparing the paintings with the ones you have done yourself for the projects. This final exercise will draw together all the threads in the rest of the book.

Haystack Rock, Oregon, USA, 30 x 40.5 cm (12 x 16 in)

While I needed to do little to the general design here I made changes to the tones, added sea mist below the distant hills and generally tried to vary the colours. I reflected the yellow of the sky into the sea and the pools on the beach to add interest and unity.

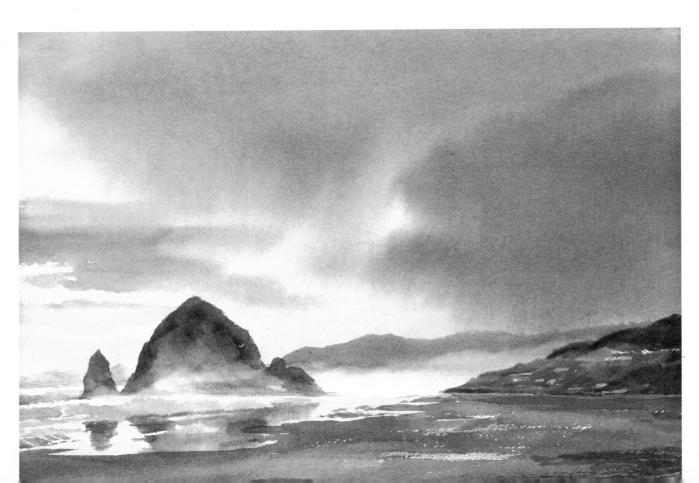

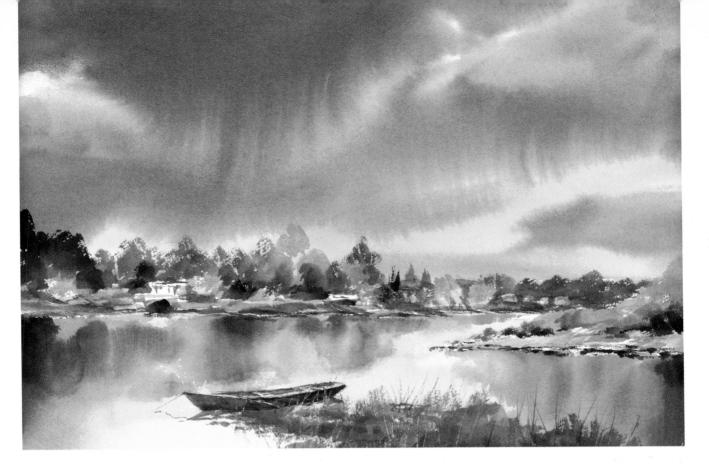

Approaching Storm over the Willamette River, Oregon, 30 x 38 cm (12 x 15 in)

This painting was very exciting to tackle. While I did not try to reproduce the dramatic clouds in the photograph exactly, I tried to enter into the spirit of the scene and put in some obviously rainbearing clouds. I kept the basic scheme of purple

and orange in mind all the time and supplemented my usual palette with Cadmium Orange. I also used Crimson Alizarin and Payne's Grey in the background trees to re-create the variety of lights and darks. It is probably obvious to the viewer that I revelled in putting in the wet-into-wet reflections on the river.

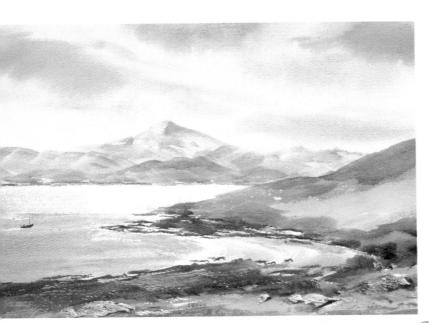

Scottish Loch, 30 x 40.5 cm (12 x 16 in)

In this painting I've dropped the horizon line, leaving more room for an interesting sky while still allowing plenty of space for the foreground. The soft wet-into-wet sky creates a good foil for the more sharply defined mountains and the textured rocks in the foreground. The little fishing boat has been added to give scale, and you'll notice that the rocky peninsula points to it.

Winter Tree, 28 x 35.5 (11 x 14 in)

In my tonal sketch I removed most of the foreground shadow in the photograph on page 64, retaining some undergrowth to balance the tree. This had the effect of leading a path into the picture and through the broken wall to the trees beyond. First I painted in the graduated blue sky, then the wood, using warm and cool colours to add variation and alternation. I simplified the structure of the tree and used dry brushstrokes with the hake to indicate the twigs. I painted the shadows quickly, making them less heavy than in the photograph.

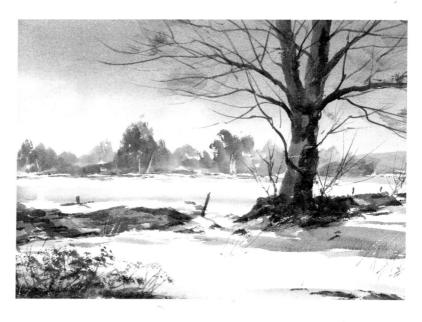

Tranquil Glade, 28 x 38 cm (11 x 15 in)

My solution to the mass of detail in the photograph was to throw the background out of focus, painting it wet-into-wet with cool colours. As I moved forward . I used richer colours. The main object is the large tree and I put plenty of colour and texture into the trunk. I used counterchange, putting light grasses against dark and dark against light.

Green Symphony, 29 x 38 cm $(11^{1}/_{2} x 15 in)$

My first task was to paint a graduated sky and the background hill together wet-into-wet. I then mixed some rich strong greens, made from Raw Sienna and Ultramarine, for the tree canopy in the middle distance and this too was painted before the background was dry to obtain a softened profile. On the bank below I added Light Red and Raw Sienna to warm the area up. The rocks below were

painted with more contrast. I then turned my attention to the foreground tree on the right, which was painted in lightly on to dry paper, but with the same mix of Raw Sienna and Ultramarine. Notice that there is plenty of variation in the right-hand foreground. I used my piece of credit card to create the rocks. The last and most pleasurable task was to put in the river with delicate, fast strokes of the brush and plenty of variation in colour.

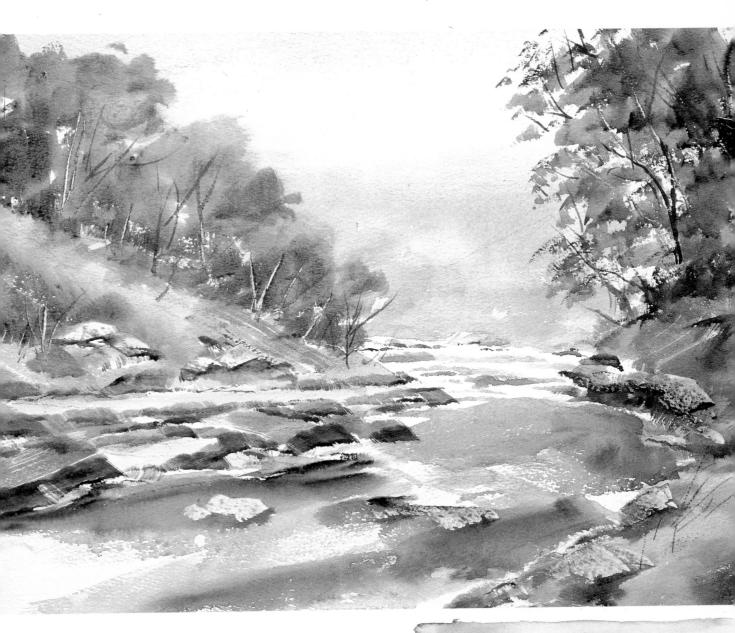

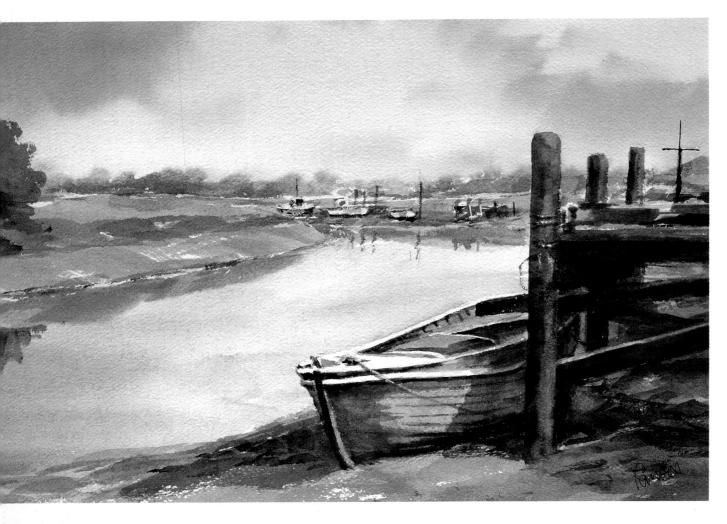

Low Tide, 28 x 35.5 cm (11 x 14 in)

The four posts on the right of the photograph were too distracting and took the eye away from the boat. However, because they are a good link between earth and sky I did not wish to remove them altogether. Instead I shortened them, which much improved the composition but still retained their important linking function. To improve the

balance, I added a tree together with its reflection to the left side of the scene and darkened the sky above it. I painted in the background trees before the sky was quite dry to give a softness to contrast with the sharp outlines of the various boats. I have restricted all detail to the foreground boat, leaving the rest of the painting loose and impressionistic—another device to direct the viewer's attention to the main object of interest.

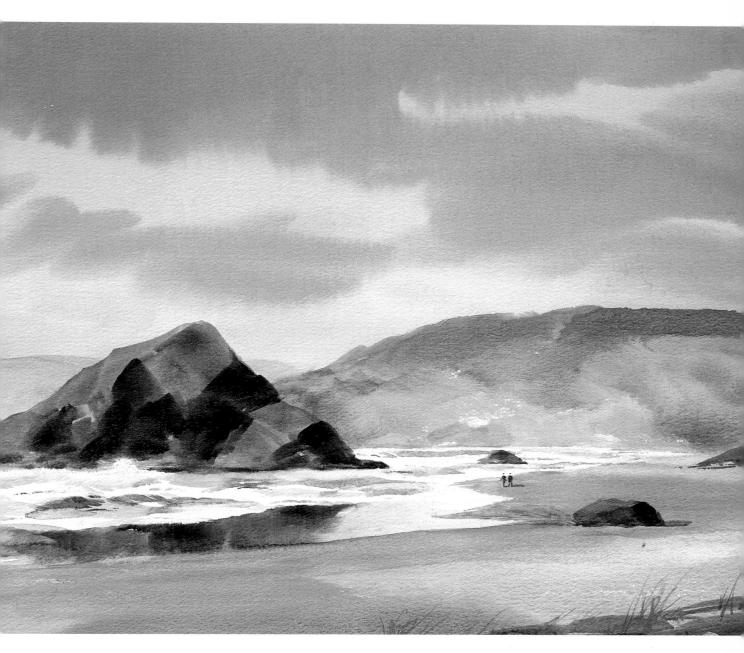

Californian Beach, 33 x 43 cm (13 x 17 in)

In my painting I have overlapped the rock with the distant hillside, thus unifying the scene more satisfactorily. I have also added a couple of figures; note that they are a different distance from each edge of the painting. I have made the sky more interesting than it is in the photograph by putting in some wispy clouds and using Prussian Blue for the clear sky. I felt that the right-hand background hill needed plenty of colour variation to make it more interesting, so I added weak Light Red to some of the green. The large left-hand rock had to be painted quickly and freely, but I still added some purples and Raw Sienna for interest. Much of the sea was left as white paper, while the stretch of foreground water mirrored the sky, but with wet-into-wet reflections. Although I did not follow all the contours when painting the sand, I did try to get in as much colour variation as possible.

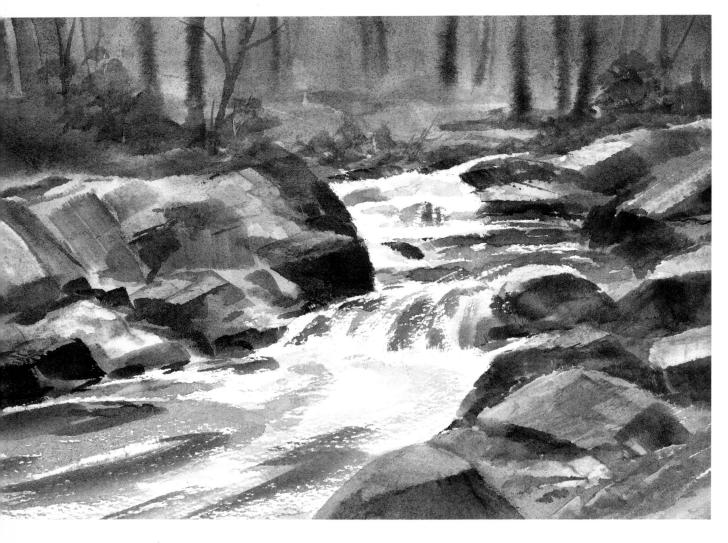

Welsh Waterfall, 23 x 33 cm (9 x 13 in)

The challenge here was to portray the movement of the fast-flowing water by using fast strokes of the hake and leaving plenty of white paper. I wanted to focus the viewer's attention upon the water, so I subdued the surrounding features. However, to add interest I put more colours into the rocks than are apparent in the photograph. I removed the rocks that jut into the frame at the bottom of the photograph, blocking the immediate view of the water. Notice how I have thrown the background woods into soft focus by using wet-into-wet technique in order to bring a feeling of depth to the picture and create contrast with the hard-edged rocks in the foreground.

Springtime Bouquet, 25.5 x 23 cm (10 x 9 in)

I made no attempt here to paint individual flowers – the aim was to convey richness of colour and strong contrast between the flowers and foliage. I've varied the colour of the foliage to avoid monotony and added more flowers to the left. The flower colours are various combinations of Lemon Yellow and Crimson Alizarin. I've also simplified the bowl itself, using wet-into-wet colours. With these flower paintings, freshness and spontaneity is all.

Smoke Bush with Roses, 20.5 x 25.5 cm (8 x 10 in)

Here I put in a wet-into-wet background of pinks and orange. I also used the same colours more strongly to paint the roses, giving just a vague indication of their petals. As the paper dried I introduced much stronger greens and copper, varying the colour of the foliage and using hard and soft edges to show up the roses. The cut-glass container is merely hinted at. I decided before I started painting that the golden rose on the left was to be the star of the show, so I lightened it considerably and counterchanged it to emphasize its importance. Finally, I added a few rigger strokes to indicate the stems.

Silk Fantasy, 35.5 x 28 cm (14 x 11 in)

This is really a wild-flower painting. I dampened the whole area behind the flowers, using mixes of Crimson Alizarin and Ultramarine. The greens were mixes of Lemon Yellow and Payne's Grey. I repeated this medley of colour as the paper dried so that the top colours are sharper while those underneath are diffused. As you see, little attempt was made to use the photograph, which was really only a jumping-off point. The container was painted in wet-into-wet and the calligraphy was put in with my rigger once the paper was completely dry.

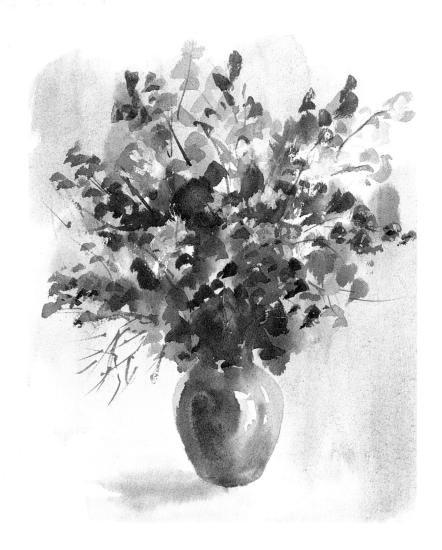

Midsummer Madness, 28.5 x 38 cm ($11\frac{1}{2}$ x 15 in)

For this painting I arranged the figures in an arc to unify them. As you can see, I placed them on one side of the picture and balanced them by putting in a dark patch of sand on the other side. I eliminated facial features completely, trying simply to convey the action. The shadows helped greatly. Two of the figures are actually the same child - I've simply changed the clothing. I've put more variation of colour into the beach than was present in the photograph.

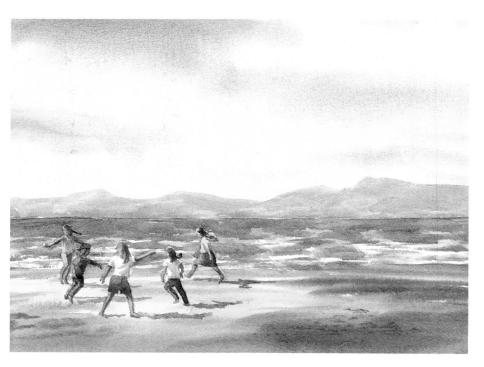

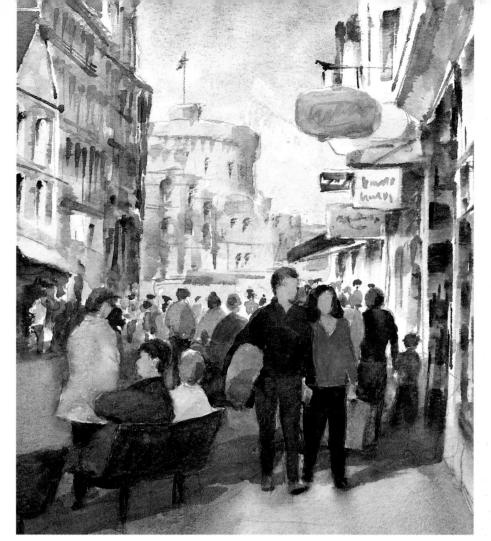

Shopping in Windsor, 25.5 x 18 cm (10 x 7 in)

I first painted in the area of sky that defined the profile of the buildings, then used the 25 mm (1 in) flat brush to paint all the architecture. I left white paper for the lights, but added colour for some of the signs. Then I put in the figures with the rigger, using stronger colour for those in the foreground. I decided to leave out the pram but added a child.

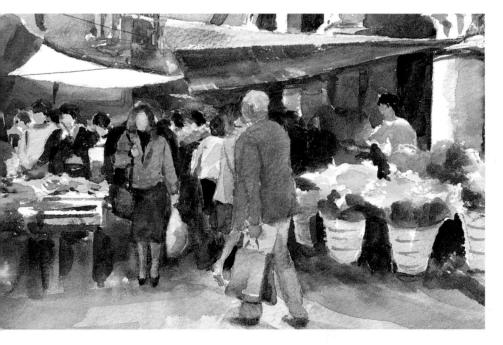

Flower Market, Venice, 23 x 30 cm (9 x 12 in)

Here I have again eliminated all facial features as well as treating the produce on sale as simple patches of colour. I've also reduced all the architectural detail. I've made the whole scene sunnier and more sparkling than in the photograph, including brightening the paving. It's not an easy subject to paint, but simplification is a big help here. Notice how I have counterchanged the figure on the far right, which helps to balance the picture.

► Back Street in Muscat, 30 x 21.5 cm (12 x 8¹/₂ in)

I felt that in my painting the drama of the shadowy arch demanded a figure, so I added one in. A painting of this kind requires more colour than is evident in the photograph for a satisfactory result, and I conjured up both colour and graduation in order to avoid monotony. You will notice this especially on the ground and the left-hand wall. I have cleared away the debris at the back of the alleyway to give more dominance to the figure and have omitted distracting, and modern, details such as the electricity cables on the right-hand wall and the water pipes on the left.

Spring Morning in Bath, 25.5 x 35.5 cm (10 x 14 in)

As always, the sky went in first after I had masked out the profiles of the buildings. To paint the columns on the left I used a dark wash and then painted the areas between the columns in a darker tone still. All other detail was put in with the corner or flat edge of the 25 mm (1 in) flat brush. The trees were painted in quickly, using the hake, the rigger and a fingernail. Many of the shadows were a mixture of Ultramarine and Light Red, and the water is a mixture of all the surrounding colours. I used white gouache to put in the seagulls.

▼ Fish Market, Venice, 24 x 33 cm (9½ x 13 in)

First I darkened the sky to pick out the profile of the buildings. I painted all the right-hand buildings in one wash, introducing various colours into the wet. I used dark, negative shapes for the fish market to show up the pillars and railings. A rich wash of Light Red and Burnt Umber was used for brickwork, and bright colours for the figures to draw attention to them. Last came the wet-into-wet reflections in the water.

INDEX

Page numbers in *italic* refer to illustrations.

a

alternation 22, 30, 118

b

balance 22, 28, 31, 36, 37, 40, 44, 50, 58, 78, 80, 102, 120, 124 brushes 13, 68, 96 flat 13, 34, 96, 104, 125, 127 French polisher's mop 13, 82, 84 hake 6, 9, 13, 34, 41, 44, 54-5, 56, 59, 62, 68, 69, 82, 96, 100, 104, 110, 118, 127 rigger 9, 13, 34, 44, 52, 54-5, 58, 62, 80, 82, 87, 104, 106, 108, 113, 123, 124, 125, 127 buildings 96-105

cameras 12, 14 clouds 38, 40, 41, 44-5, 46, 50, 51, 60, 78, 117, 121 colour experimenting with 82 of sky 38-40, 108 variation in 11, 20, 126 warm and cool 27, 29, 30, 32, 48, 55, 65, 118 in water paintings 68-9 colour wheel 6, 29 colours 13, 29, 44, 46, 60, 108, 110, 117, 118, 119, 121 dropping in 82 in flower paintings 82, 123, 124 composition 16-21, 58, 64, 65, 80, 100 and design 22-31 contrast 16, 22, 24, 25, 28, 31, 37, 38, 40-1, 46, 56, 60, 65, 66, 70, 72, 74, 88, 110, 119, 122 counterchange 37, 69, 82, 84, 86, 88, 91, 123, 125 credit card (as tool) 32, 35,

55, 69

cropping 74

depth of field 18, 54-5, 65, 70, 74, 110 design 22-31, 40-1, 80 dominance 22, 25, 37, 41, 51 dry brush 76, 118

enlarging 15 equipment 12-15 estuaries 68, 78

fast and loose technique 84,86 figures 83, 88-96, 105, 121, 124, 125, 127 flowers 80-7, 123, 124 format 74

gouache 11, 52, 80, 98, 127 graduation 22, 27, 31, 41,

lakes 69 lead-in 16, 46 lenses 14 light meter 38, 102 lighting 83, 84

overworking 66, 96

paper 13 cartridge 12, 32 tracing 12, 88 transfer 15 untouched 9, 34, 58, 62, 110, 113, 121, 122, 125 watercolour 34 pencils 12, 32, 34 perspective 79, 99 prints 14-15 projectors 14, 15

Ranson, Ron Afternoon Sunshine 1 Approaching Storm over the Willamette River, Oregon 117

Australian Peninsula 72-3 Back Canal in Venice 96-7

Back Street in Muscat 126 Bigsweir Bridge 115 Bluebell Wood 83 Californian Beach 121 Chepstow Castle 20 Cliff Path, Kalymnos 88-9 Donegal Lakes 48-9

Evening Light, Severn Estuary 42-3 Evening on the Loch 46-7 Fish Market, Venice 127 Fjord in Lofoten 32

Flower Market, Venice 125 Greek Beach 4-5 Greek Island Village 99 Green Symphony 119 Grounded 22

Haystack Rock, Oregon, USA 116 The Hill in Orta, Italy 102-3

Iris and Fasmine 80-1 Last of the Snow 44-5 Low Tide 120

Low Tide on the Severn 38 Market Cross at

Malmesbury 100-1 Market Square in Orta, Italy 92-3 Midsummer Madness 124 Misty Creek 56-7

Misty Hills 76 Morning Sunshine 52 Oregon Lake 70-1 Porlock Weir 11 River Bend 59 River Gorge 74-5

River Mist 110-11 The River in Winter 77 The River Wye 108-9 Scottish Loch 117

Shadows Across the Lane 112 Shopping in Windsor 125

Silk Fantasy 124 Smoke Bush with Roses 123

Spring Morning in Bath 127

Springtime Bouquet 123 Sun on Snow, Oregon 9 Sunlit Daffodils 85 Tranquil Glade 118 Tumbling Water, Oregon 6 Village on Kalymnos 31

Waterfall Near Glencoe 16 Welsh River in Flood 66-7 Welsh Waterfall 122

The White Barn 60-1 Winter Reflections 62-3 Winter Shadows 58 Winter Tree 118 Woodland Stream 106 Yellow Roses 84 reflections 42, 66, 68, 69, 70, 77, 105, 116 rivers 62-3, 66, 68, 74, 76-7, 106, 110, 114-15, 119 rocks 66, 72, 79, 110

scale 88, 91 seascapes 68, 69, 72-3, 78 seasons 106-15 shadows 22, 40, 58, 59, 64, 77, 78, 91, 98, 102, 112, 113, 118, 124 sketch pads 32 skies 38-49, 50-1, 62-3, 78, 105, 110, 115, 117, 118, 120, 121, 127 snow 9, 44, 58, 62, 64, 77, 106, 108, 113, 115 street scenes 8, 90, 92-3, 100-1, 125, 127

tonal sketches 12, 19, 26, 32-7, 42, 70, 72, 74, 86, 99, 104, 106, 110, 118 tonal values 18, 20, 32, 104 trees and woodland 52-65, 76, 77, 83, 106, 108, 112, 118, 119 tripods 14

unity 22, 26, 31, 38-40, 74, 79, 80, 121

variation 11, 22, 30, 41, 77, 116, 118, 119, 121, 124, 126

W

water 38-40, 56, 62, 66-79, 105, 122 wet-into-wet 16, 42, 52, 55, 56, 59, 65, 70, 76, 82, 85, 87, 88, 106, 117, 118, 121, 122, 123, 124